still raising hell

*Poverty,
Activism
and Other
True Stories*

SHEILA BAXTER

*Press Gang Publishers
Vancouver*

The Publisher acknowledges financial assistance from the Book Publishing Industry Development Program of the Department of Canadian Heritage, the Cultural Services Branch, Province of British Columbia, and the Canada Council for the Arts.

Permission to reprint photographs is acknowledged as follows: photos on pages 37, 49, 51 and 67 are by Sheila Baxter; photos on pages 79, 98 and 99 are Copyright © J. Vanson and Lyla Smith, submitted by Sharon Kravitz; photos on page 120 are reprinted with permission from Bob Sarti; photos on pages 134–5 and 146–7 are reprinted with the permission of the subjects; the photo collage on page 152 is reprinted with the permission of Yasmin Jiwani. Any photos not credited are from Sheia Baxter's personal collection. Graphics on pages 23, 40 and 43–44 are reprinted from *The Long Haul.*

CANADIAN CATALOGUING IN PUBLICATION DATA

Baxter, Sheila, 1933–
 Still raising hell

ISBN 0-88974-076-3

 1. Baxter, Sheila, 1933– 2. Downtown Eastside (Vancouver, B.C.) 3. Community development, Urban—British Columbia—Vancouver—Citizen participation.
4. Poverty—British Columbia—Vancouver. 5. Social reformers—British Columbia—Biography. I. Title.
HN110.V3B39 1997 362.5'09711'33 C97-910699-0

Edited by Barbara Kuhne
Printed by Best Book Manufacturers
Printed on acid-free paper ∞
Printed and bound in Canada

Press Gang Publishers
225 East 17th Avenue, Suite 101
Vancouver, B.C. V5V 1A6 Canada
Tel: 604 876-7787 Fax: 604 876-7892

To all fat people and poor people who are oppressed. Don't ever give up the fight. We have rights; unfortunately we have to fight for them. And to Sheila, the child within. Thank you. We made it. I love you.

Contents

Acknowledgements

Thanks to:

Barbara Kuhne for saving this book;
Andrea Imada for her support, encouragement and technical assistance;
Everyone who contributed to this book, including those who worked so hard on gathering statistics;
Carnegie friends for their support;
and Press Gang Publishers.

Introduction

This book began with my wanting to write about the birth of the anti-poverty movement in the 1970s. I also wanted to find out what makes other activists resist and fight for the issues they believe in. What makes some people put their bodies on the line for community issues while others just accept injustice? What makes an activist?

I interviewed many activists of different genders, cultures, sexual preferences, ages and classes. A few of their stories are included in this book. Activism is not a dirty word. The activists I interviewed are people who care about other people and this planet. The common thread among them is that they are working to make the world a better place. A world without activists would be a world with no hope for a better tomorrow.

Believing one has the power to make a difference is truly empowering. Standing up to injustice and abuse and corruption gives you power. Some folks drink or drug their powerlessness into oblivion. My solution is resistance. If you need a stop sign on your street to save your kid's life, organize it. If you've been fired and feel you've been mistreated, fight back. If your local politicians aren't doing right by your community, have a sit-in at their office. If your community needs a women's shelter, it could start with you getting a group together. If you believe poor people have rights too, call the newspapers when their headlines trash people on welfare. Try fighting back. You may just put your Valium away forever.

While I was writing this book I was diagnosed with Graves disease.* This led me to include some thoughts on health and

*Graves disease is an enlargement of the thyroid gland, with heart palpitations.

aging and dying. I also kept a journal for a year, recording activism in my community. I began to see how this book was like a quilt, with each square a piece of history, my own or my community's.

Many women before me have made fabric quilts that showed their family histories. Each scrap of material, each pattern, was a memory of something passed on, perhaps dreams of freedom. Each quilt held many messages. My book is such a quilt, stitched together with poverty's thread and very little trimming.

Most of the material in my quilt comes from my journals and my daily experiences. Some comes from the attic of my mind and some from resources I have discovered. My quilt is set down on the page in black and white, but in my mind's eye it has a rainbow of so many colours: blues, greens, yellows, reds, purples.

I've known for a long time that I'm different from most people I meet. I seem to get a power surge in my brain that tells me to resist when something is unjust. When I speak out, write or demonstrate against wrongs, I have a strong sense of spiritual support. I think my three previous books about injustice were spiritually guided: how else would they have gotten published? I am not an easy writer to publish. I type on an old Smith Corona (cost me $39 at a thrift store) and some pages are messy and coffee-stained. I've taken a computer course while writing this book; perhaps I will get lucky and get a computer by the year 2000.

We the non-academic, working-class poor don't have many books that speak our true voices. Often when someone like me writes, our thoughts are reconstructed by others who feel that education brings the authority to interpret our meaning. I have so many memories of speaking and being interpreted. People say things like, "What Sheila is trying to say is . . ." or "What Sheila means to say is . . ." or "What Sheila meant was . . ."

When I speak from my working-class perspective I know what I say and I know what I mean. I have an uncanny knack for seeing through bullshit.

As a writer I am grateful to have publishers who understand where I'm coming from and who are committed to preserving the voices of the working class.

My books are easy to read but the contents are often harsh.

A Cockney Childhood

I was born in 1933 in East London, within the sound of the bells of St. Mary-le-Bow Church. That makes me a Cockney, although I have long since lost my accent.

I lived with my mother and my father and my sister in a council house that was one of many council houses in our neighbourhood. Our front steps, like those of the other houses, were shared with a neighbour. Most families whitewashed their steps and polished their brass letter boxes and mail slots. When things got bad at our house and my mother fought with the neighbours, the women next door whitewashed only their side of the steps. Our side was dirty and grey, like the inside.

The front door of our house opened onto the stairs leading up to the bedrooms. My mother and father shared one room, my sister and I the other. Each bedroom had a fireplace, but we lit these only when someone was sick. On the ground floor of our house there was a living room and a small scullery with a cold-water tap and a cupboard for the coal. I was scared of the coal man, who would arrive covered head to toe in black dust. The council houses had no indoor toilets; the toilet was out back at the end of our small yard. In the house we would use a bucket. I can remember when I was small carrying the smelly galvanized bucket up to my father, who would yell down the stairs for it in Pig Latin so that the neighbours couldn't tell what he was saying.

The war was just starting, and gradually all the windows on our street were criss-crossed with tape for protection from bomb blasts. Men came one day and dug up our back yard to install a cement air-raid shelter. We never used it, though. Instead, like our neighbours, we'd take our bedding down to the

tube (subway) station at the end of the street. Rows and rows of metal bunk-beds filled the station every night. We were instructed to carry gas masks at all times, and we had drills and had to wear the masks. I remember gagging when the mask was placed on my face. That is the most scary, claustrophobic memory for me.

I loved to play on the street. All of us kids were poor, so we had no sports equipment. We had tops that spun when you whipped them with string and we made scooters by attaching wood planks to old roller-skate wheels. We would push these to the top of the hill, then get on them and fly down. At dusk we would play Tin Can Tommy, a game of hide and seek where you try to find the hiders before they can grab the tin can. We played statues, where you have to freeze like a statue, and jacks, with pebbles. The great joy of life was when someone gave you a few pennies. Off to the fish and chips shop then to buy some chips, golden brown with salt and malt vinegar. I can still taste them now.

I was very proud when my parents used to send me to place bets with a man who lived twelve long blocks away. I was instructed to look out for the rozzers—police—and not to deliver the money if any were around. I guess I was a bet runner as a child.

Pawn shops were also part of our culture. Suits and shirts and wedding rings were held at the pawn shop in return for borrowing a little money till payday. I thought this was normal. For many working-class people it was. The Cockney Pearly King and Queen were also part of my childhood. The Queen wore clothes covered in white pearl buttons and a hat with a long feather. I thought of *her* as my real queen, not the Queen of England.

The people who had the council houses built didn't think poor people needed to wash, so none of us had bathrooms. If I was lucky, I could get a few pennies sometimes to take myself off to the public baths, where a woman wearing a white uni-

form would run water for you in a cubicle and give you a towel and soap. How good it felt to run the soap on my legs, white lines mixing with grey as the dirt of a week or two was washed off. I constantly got boils, which the school nurse painted with a purple ointment that stayed on my skin for weeks. Lots of my classmates had purple arms and legs just like me. The school nurse also checked us for head lice—the treatment for that was the same purple ointment—and we would often be sent home with a note saying we had fleas.

School was a nightmare during the war years. Teachers and children huddled together in damp basement rooms that were sandbagged so that no light could escape. In these windowless tombs, our fear and terror created a dim mist. We learned our eight-times tables as the bombs whistled down outside. For our English teacher it was a constant battle to erase our Cockney accents. "How Now Brown Cow," she would instruct us to repeat, but it came out sounding rather different. When we left school for the day, we never knew if our houses would still be standing or if our families would be dead or alive when we got home.

My father was called up to serve in the army, and when he came home he and my mother would have terrible arguments. One Sunday afternoon I was playing with some friends from school when a bunch of kids came yelling up the hill, "Sheila, there ain't just a fight going on at your house. Sounds like they're killing each other." I ran home, fear gripping my throat. My mother had stabbed my father, and there was blood all over the faded wallpaper. My mother had two black eyes. My parents separated soon after that and my father left. But not before they had one more violent fight.

"I don't want her," my father yelled angrily.

"I don't want her either," my mother screamed. "Don't leave me stuck with her, you bastard. Take the fuck off and take her with you."

As I heard those words, I knew that what I had feared all along

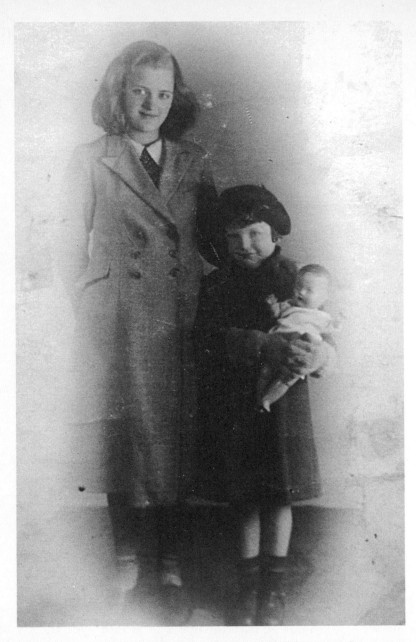

Sheila and her older sister, Rose, on the day before they were first evacuated during World War II.

was true: they didn't want me. They didn't love me. I ran upstairs to my barely furnished bedroom, sobbing, lying on a cold bed that had no blankets, just old coats spread out. My sister, who was working at the time, also moved out, leaving me alone with a raging alcoholic woman who beat me and abused me, and worst of all wasn't able to love me.

After my parents separated, my father and his girlfriend rented two rooms from my grandmother Daisy. My father's girl-friend wouldn't allow me to call him Dad when we were around other people. My mother used to go to my grandma's house in a drunken rage, dragging me with her. We would take the bus, she muttering threats, me too scared to defy her. I remember once arriving at Daisy's and nobody would open the door for us so my mother broke off a piece of the garden fence and tried to break the parlour windows, yelling and swearing all the while. I desperately wanted to be safely inside with Grandma Daisy, but I was stuck with my mother, who took out her rage on me.

Often I would go to the Commons and walk among the trees, talking to them and crying. I thought the weeping willow was just like me. Sometimes when my mother was drinking and things were unsafe at home, I would sleep out there under the trees.

On more than one occasion I ran away from home and walked the twenty miles to Daisy's house. Once when I was about fourteen, I walked all those miles on a Christmas Eve. I stood across the street looking in at my cousin Danny, who lived with Grandma, but they wouldn't let me in because they thought my mother had sent me to make trouble. Come dawn on Christmas day, I walked all the way back, exhausted and hungry. I let myself in the unlocked door and thanked god that my mother was sleeping. I felt so bad, I wished I were dead.

After that I was determined to get away from the abuse. I truly believed that the next time my mother came after me with a knife, she would slit my throat. Again I walked to Daisy's. This time I was infinitely relieved that my father opened the door. I said clearly and firmly, "If you don't take me away from

her, I will throw myself under the next bus that comes along."
Grandma was in the background urging him to let me in. She
would defend me to my father's girlfriend, saying, "She's *his*,
don't treat her like that."

I never had to return to live with my mother, though I stayed
with various relatives until I could work and support myself.

I know I was evacuated twice during the war. The first time I
was about seven, the next time a few years older. When my sis-
ter and I arrived at the first foster home I was ashamed when my
clothes were unpacked. At home I slept in my knickers, but here
the kids had nighties. The lady was very kind and made me a
beautiful green cotton nightie. I had never seen a treadle sewing
machine before so of course I stuck my finger under the needle
and when I pushed the wheel the needle went right through my
nail. How that hurt!

We evacuees were different from the other kids and we were
disliked for it. We would be excluded from birthday parties the
other kids went to, and were made to feel like outsiders.

At some point I ended up in an abandoned laundry facility
with many other evacuee children. We had head lice, scabies
and impetigo and many behaviour problems. There was no bath
there either. We slept in rows of little camp cots. I wet the bed
often, and my punishment was to stand in a corner with my wet
blanket over my head. I wasn't alone in this, some older kids did
it too. The others would torment us for being bed-wetters. We
weren't beaten by our caretakers, just ignored and neglected.

I remember being so hungry I would eat anything: rotten
apple cores, spit-out gum wads, raw potatoes I found in a
farmer's field. Once I stole some cabbage leaves, and I can still
remember how they tasted.

The second time I was evacuated I was nine and had just started
my period. When we arrived at our destination we stood in a
schoolyard while people from the town came to choose their
foster children. I was tired and hungry and among the last to be

chosen. My mother had told me that I needed to be watched now, especially around boys, or there would be trouble. I had no idea why, but it worried me. When a woman finally chose me I told her, "My mum says you gotta watch me cos I gets me period."

When I was back in London with the other Cockney kids, I remember running an errand one bright sunny morning. The air-raid siren went off but I didn't go to a shelter because I was afraid of getting in trouble if I didn't get home with my package. A huge silver rocket went screaming so close by me that I could see the markings on it. I came to accept bombs and pain and abuse as a normal part of a child's life.

When I was a bit older I remember the Yanks (American soldiers) driving around offering us gum. One stopped his vehicle and gave me something I had rarely seen, an orange. It was stamped Sunkist and he asked me if I knew what that meant. Of course I didn't. "It means when the sun goes down I will kiss you," he said. I took the orange but my instincts told me there was something not right with the look on his face. Young girls were there for Yanks to pluck, he implied, but he didn't pluck me.

Battle with Mr. Smith

The eleven-year-old with budding breasts
Opened the door of Mr. Smith's beer store
Darkly lit with wooden-beamed ceilings,
Creaky dirty wooden floor
And of course, at the counter
The pale-faced, beady-eyed Mr. Smith
Who always stared at her breasts.
Mr. Smith's father had hung himself
From those beams
Years ago it was said.
She was scared of Mr. Smith
And the ghost of his father.

Some nights she had to go to the store
More than once, it depended
On how drunk her mother was.
Anxiously she would watch
The large screw-top beer bottles become empty
Knowing that she would have to return
To Mr. Smith's beer store
To beady-eyed Mr. Smith.
If the store was empty
He would come around the counter
And try to fondle her breasts
Usually she managed to wriggle away.
Mr. Smith was at the counter that special day.
Come round here, Mr. Smith said
Come behind the counter.
She said, no, no I don't want to.
But you are just like your mother, Mr. Smith said
You are your mother's daughter.
Come here, come behind the counter
I want to show you something.
She became enraged
Fear left her
She yelled and pounded her small fists on the counter.
I'll never drink
I won't smoke
I'll never hurt my children.
And she never did.
And Mr. beady-eyed, pale-faced Smith
Never bothered her again
And she was no longer scared.
He was just a dirty old man
Who owned a beer store.
No woman or child should ever
Accept labels from beady-eyed Smiths.

Remembering the Cockney child that I was, I'm proud of how I survived, how I kept my promise not to follow in my mother's footsteps.

Making Poverty the Issue

REVISITING THE 1970S

In the 1960s, I was a housewife and mother living on Selby Street in Montreal. It was a working-class neighbourhood with train tracks running along the back of our yards. Some people on our street had lived there all their lives, but we were all evicted so that the Trans-Canada highway could go through our neighbourhood. After that we lived in Verdun, another working-class poor area. We were a mixed neighbourhood; some streets were primarily English families, others French. In many families, one parent was English and the other French. Our kids all played together. Rents were cheap.

On the street where my family lived, there were rows of two- and three-storey flats with outside steps that froze in winter. Most of the flats had small balconies. On hot summer nights, when the tin roofs made ovens of our flats, everybody would squeeze onto their balconies to sleep. Mornings would see kids asleep, covered with an assortment of blankets and sleeping bags.

We lived in a third-floor flat. We had three bedrooms, a dining room, a TV/sitting room and a small kitchen with a gas stove and an old-fashioned wringer washer. Our clothes would be pegged out on the line all year round. In the winter, our clothes would freeze solid, so we'd string our clothesline in the house, along the hallway or around the kitchen. Our flat was heated with oil, which was expensive. Sometimes if the oil ran out we would turn on the stove and open the oven to warm up the flat a little.

The smells of bread baking, laundry drying and soup on the stove are pleasant memories from that time. Neighbours would visit one another for coffee and our kids all came home from

school for lunch. Neighbours watched out for each other's kids, leaning out of windows and off the balconies as the kids played or went to and from school. We knew which husbands were drunks and which women were getting beaten up. The woman next door made us all happy when she fought back after a lot of abuse. While her husband was sleeping she boiled all his underwear in bleach (because he had been sleeping with another woman), then threw all his clothes over the balcony to the ground. Our family had its share of fights and problems too. My husband would get drunk at the Legion and come staggering home down the street. My neighbours would give me sympathetic looks, just as I did when their husbands came home the same way.

It was the 1970s, and many things were in the air. I volunteered to work on a community newspaper called *Up to the Neck*, dragging my small kids with me in the afternoon. I loved writing small poems and then seeing them in print. It was a political paper, and I started to learn a lot. I started to understand a little about why I was poor, that poverty was a social problem. *The problem was not me.* I also started to learn about women's rights, and about why French Canadians were so angry.

I was part of the beginning of the anti-poverty movement in Montreal, working on issues like slum landlords, welfare and UI rights and bailiff seizures. Some organizers were paid to work with the poor. We held kitchen meetings in our walk-up flats. The big issue was welfare rights: there didn't seem to be any. Representatives from various communities would come together once a month at Columbia House in Point St. Charles. The umbrella group was called the Greater Montreal Anti-Poverty Co-ordinating Committee. The issues were serious, but afterwards people would socialize at the bar or over coffee and *patates frites*.

The anti-poverty movement grew and grew. We held many demonstrations. In one of our demos we occupied the head office of the welfare ministry for eleven days. A hundred or more of us camped out there, sleeping on the floor with our children.

Executive washrooms had lines of diapers and underwear hanging to dry.

It was at that demonstration that I first met Bill, a black man from the southern U.S. He came over and sat on the floor beside me, telling me he was looking for an apartment because he was going to be working in Montreal as the director of Ville Marie Social Service Centre. His wife and family were coming to join him.

There was another organizer who had come up to Montreal from the southern U.S. too, Bob. After the kids were asleep and the lights were dimmed, we all would sit around in groups and talk quietly. Bob would tell us great organizing stories long into the night. The seeds of political awareness were being sown, and in many of us they grew and blossomed.

Sit-in becomes feed-in

A group of 40 Montrealers who have been occupying St. Denis St. Provincial welfare offices since Tuesday morning yesterday turned their "sit-in" into a massive "feed-in."

They invited other welfare recipients to join them for lunch and more than 200 "guests" showed up.

The welfare recipients said they will not leave the building until the government decentralizes welfare services, provides parity of rates for all recipients and makes available immediate assistance for emergency cases."

—*The Gazette*, Montreal, 17 July 1970

During the occupation of the welfare office, food and support for us just poured in. Most of us were on welfare, most of us were women, and many of us became strong activists. We won our demands, but some of us didn't want to leave because the food was so good and there was such a strong sense of belonging, of not being alone.

There were lots of other demonstrations. At one I got arrested. It was very scary being hauled off in the paddy wagon and being

interrogated by black-leather-jacketed cops. We were detained but not charged in the end. I called my husband from jail. He said in his broad North Ireland accent, "You can fucking well stay there." He hated my anti-poverty work. I wasn't baking so much bread and I wasn't always home for supper. I took the laundry to the laundromat. I had started to want a different kind of life.

Welfare protesters hit arrests

The 22 persons arrested for common assault Monday in the Atwater Market welfare offices yesterday charged the province's welfare system itself is guilty of assault. . . . "The assault charges were laid even though no accusation has been made that the arrested persons physically injured anyone, damaged property, or threatened to do so," stated Gerry Murray, co-chairman of the Greater Montreal Anti-Poverty Co-ordinating Committee (GMAPCC).

—*The Gazette*, Montreal, 18 March 1971

One day one of the local organizers told a group of us that they were going to apply for Local Initiatives Project grants (government-subsidized employment) to allow each community to have a storefront centre with paid staff. At that time most of us were volunteers. There were hundreds of us all over Montreal. Once the grants came through, about one in a hundred of us got jobs in the storefront centres. Some of our bosses abused their positions of power, and some of those who had jobs worried about losing them if the volunteers got too powerful. Gradually things started to fall apart. Our demonstrations showed a huge decrease in people power. The movement got sicker and sicker, and gradually the storefronts closed.

During this time I was chosen to go to a people's training program in the school of social work at McGill University. I was paid to attend, and I got a job afterwards as a community organizer at the agency where Bill was the director. I had left my husband by then and was living with my kids in a couple of

furnished rooms. Bill wanted a team of organizers to work at the grassroots level in my community and I was one of the people he hired. One of my assignments was to find out the needs of the people "on the wrong side of the tracks." I asked a lot of homeless women what they needed and from that came my plans for a day shelter for street women.

I remember sitting in the staff room surrounded by professional social workers, one of whom said sarcastically, "Oh, Sheila wants to be queen of skid row." But Bill gave me the trust and the freedom to be creative in my community organizing work. When I got the go-ahead to start a shelter, I formed a committee: a retired accountant from a respectable firm to be the treasurer, a retired sociologist to co-ordinate research and stats, a woman who was great at writing proposals to put our proposal together. It took two years of tireless work to convince the community of the need for a women's day shelter, to obtain financial backing for the project and to choose a suitable location and recruit staff. The centre, called Chez Doris,[1] opened in

Sheila (on the left) with the original staff at Chez Doris on St. Antoine Street, 1977.

March 1977 on Mountain Street just below St. Antoine. It began in a small apartment over an all-night restaurant. It had four small rooms and a bathroom and was reached by a long, steep, wooden staircase. The restaurant was a hang-out for pimps and prostitutes, most of whom were connected with a close-by nightclub. The original staff of Chez Doris had no professional training but had all experienced problems similar to those of the women they were working

with, and all had lived at one time near the poverty line. In the time since I left Montreal, Chez Doris has grown and is now run by professionals. In 1992 I was invited back as a special guest at the fifteenth-anniversary celebration.[2]

I learned a lot about organizing from some great organizers. I also learned that some organizers manipulate people in the name of the movement. Back in the 1970s in Montreal, one organizer told us not to worry about the laundry and the house-work, that the movement had to come first. So we women marched, occupied buildings and demonstrated, bringing our kids with us. One day I was walking in the richer part of Montreal and recognized the address of one of the organizers. I stopped in to say hello. There was a woman cleaning the house, hanging rugs out on the patio (she was called a charwoman at that time) and a nanny looking after the children. I went back to my third-floor flat in Verdun, back to endless dishes, childcare, cooking, washing with no automatic washer or dryer. It seemed there was one rule for the poor in the movement and a better rule for the middle-class organizers paid to organize the poor. It was a good lesson in classism.

Nina Bruck and I became friends when we both lived in Mon-treal and we've stayed friends for over twenty years. She came from a privileged class and my family was working class, so it was a challenge to bridge the gap between our worlds. But she is a poet, a writer, a woman with strong opinions—quite an eccen-tric, like me. I remember when Nina first brought me and my kids to her home in Westmount. When my youngest son, Billy, swung on a priceless antique chair, it was a difficult moment. Nina's husband, Gerry, was concerned, to put it mildly. Later we invited them to our third-floor flat in Verdun to a working-class party, and unknown to me, someone offered Gerry a toke.

Nina and I haven't always agreed on everything but there is a
mutual respect that has lasted through the years. When I wrote
her about this book she shared these memories of the seventies,
when we were both involved in anti-poverty work.

Letter from Nina

Montreal in the seventies, a murky Monday morning,
me do-gooding with all those boxes donated to
GMAPCC (Greater Montreal Anti-Poverty Co-ordinating
Committee) by manufacturers of children's wear. There
were more pink nylon party dresses with layers of crino-
lines than warm snowsuits or tough blue jeans. You
loomed upout of the gloom, "What the fuck do you think
you're doing pitting one group against the other for all
those dumb dresses?"

From this opening scene we went on to become friends.
The vast fridge in our Westmount home was such a disap-
pointment to you: "What, no steaks!" Your kids, always so
open, delighted us with things we never knew. There were
demonstrations for or against all sorts of things, in front of
ugly buildings, and you instructed us in self-defence: "If
the police come, just split."

It's fall in a Dickensian factory warehouse along the
Lachine Canal, women tying ribbon bows for Halloween or
was it Christmas, and you and I bent on matching socks
from the mountains of samples contributed by a large textile
company, odd colours and sizes in one gigantic box. Two
hours later, after we had married off only light pairs, you
tossed the colourful orphan socks into the air, declaring,
"From now on, odd socks are in!" And we laughed and
laughed until we cried.

Nothing sacred, nothing scared you (that mouse on
the St. Urban Street stairs doesn't count) and then you split
for good to Vancouver, B.C. Come back someday; we need

you here now more
than ever.
Nina

All dressed up for Sun-
day School: Sheila and
family (four children and a
foster son) in front of their
Selby Street flat in Montreal.

WHERE ARE WE GONNA DEMONSTRATE TODAY, MA?

When my children were young I often took them on demonstrations with me. Recently I decided to ask them what their recollections are. I wondered what effect my activism had had on their lives.

My youngest son, Bill, is now married and has two children. He runs a thriving business in Vancouver. Here are some of his memories:

Bill

I remember kicking a cop in the leg because he was trying to take away my mother. It was when we were trying to save low income houses from being abolished in Montreal. I was about eight at the time. The cop told my mother, "If you don't want to be arrested, take your son and get out of here." The police were dragging the women out of the house by their hair.

I also remember when we took over the Hydro Quebec building. It was mostly mothers and children, not many fathers. We slept on the floor for three or four nights, we wouldn't leave. It was like a great playground for us kids. The protest was about welfare rights.

17

Even earlier than that, when I was about four years old, I remember a big demo we went to in Montreal that was on St. Helen's Island. They were going to close the park to build the site for the World's Fair, Expo '67. I was wearing a T-shirt that said "Give back our park" and I climbed a fence marked "No trespassing." A press photographer took my picture and it made the front page of the newspaper the next day.

I asked Bill how my activism affected him and whether he has stayed an activist:

It made me aware that there is a lot of injustice in the world. It helped me grow to understand that just because educated people and politicians say something is right, you don't just believe them. It pays to make a stand for what you believe in.

For a while I was a volunteer at the G.F. Strong Rehabilitation Centre, helping with wheelchair basketball and motor soccer. I believe in the philosophy, "See the person before the wheelchair." I want people to see the positive side, what they still have and what they can do, like Rick Hansen did.

My youngest daughter, Colleen, shared these memories:

Colleen

I remember when I was about six years old going to Ottawa on a bus and singing, "Trudeau is a bastard, he shall be removed / Like a tree without any water, he shall be removed." We wore white T-shirts with slogans painted on the back when we demonstrated around the Parliament buildings.

When I was about eight I remember a sleep-in at the St-

Denis welfare office. Mostly I remember all the good food, compared to what we had at home. Restaurants donated pizza, chicken, turkey, Chinese food. We kids waited for people to finish their pop drinks so we could run to the store to cash them in for candy.

I also remember when Margaret Collins, who was our neighbour and worked in the anti-poverty movement, started a Worm Drive to help fight poverty. She paid the children one cent per worm. During the summer we went to people's lawns at night-time with flashlights, collecting worms. They were kept in boxes and sold to someone who sold them for fishing. But eventually the worms escaped from her shed.

The influence of my activism on her adult life:

I think it's great that people make the effort to express themselves when they feel strongly about an issue. I would take my children to a demo about something that I care strongly about. The issues that are important to me are child poverty and child abuse, racism and violence against people. I am involved in the area of childcare and work hard to make a positive contribution.

My eldest son, John, who has worked at the CBC (Canadian Broadcasting Corporation) for over a decade, shared these thoughts:

John

When I was about ten, I remember we had a fundraiser corn roast to help people facing eviction on Selby Street in Montreal. I also remember a sit-in on St-Denis where we stayed for over a week. When I was a bit older, fourteen or fifteen, I learned to use video equipment. At the time the anti-poverty groups were using video cameras to record

actions and I went to a demo and tried to tape the Minister of Health but he refused to speak while I was filming. When I was sixteen I was hired on a LIP program (Local Initiatives Program) as an advocate for a group called CRAB (Citizens' Rights Against Bailiff seizures).

I asked him what his feelings were about his involvement:

I was never scared and I never felt my safety was threatened. There was clearly a difference between criminality and civil disobedience. I never thought the police would hurt us. For me the sit-ins and demonstrations were festive and empowering. My memories are positive on the whole. There was an older activist who was a role model I wanted to emulate when I was sixteen. I think it helps to expose kids to people who are breaking the cycle of poverty. Do I still go to demos today and would I take my children? No, I'm jaded, I find most demos a waste of time. But you, Mother, take care of bringing my kids to demonstrations.

My eldest daughter, Suzanne, is an urban refugee living in the sunny Okanagan in British Columbia. She shared some of her memories:

Suzanne

I can recall lots of interesting people sharing their points of view and coming together to voice their concerns. There was a great sense of teamwork, co-operation, and a sense of empowerment. If we had planned a demo and it rained, we all wore large garbage bags to keep us warm. I remember one demo in Montreal when I was in my pre-teen years. I was draped in a black cloak at the head of the march, carrying a picture of a young girl who had commit-

ted suicide while in custody. We were protesting the care
children were given while in custody. Another event was to
voice the need for safe bicycle paths. During mid-day rush-
hour traffic we wore gas masks and lay down on St.
Catherine's Street in downtown Montreal, stopping traffic
to educate the public about the need for safer bike paths.
Our concerns were heard and now Montreal has some of
the greatest bike trails.

I asked Sue what impact her childhood exposure to demonstra-
tions had on her:

As an adult, looking back to when I was a child and
exposed to your participation in protests, it gave me an
awareness of the power within me to voice my concerns
and to make a difference. I became educated about new
concerns and I am thankful for the experiences I had.
Information is power—Pass it on!

In my current life, the issues that are important to me
now are:

- Promoting awareness of childcare issues.
- Being part of a Parent Advisory Committee at my chil-
 dren's school.
- Celebrating International Women's Day—I'm proud to
 be a woman.
- The annual Peace March, promoting world peace.
- Arbor Day and Earth Day, informing the community
 about environmental issues.
- The Canadian Cancer Society.

My foster son, Jimmy, was with me from when he was six till
sixteen. I asked him what he remembered about those times
when we demonstrated for our rights.

Jimmy

My first demonstration was when I was nine years old. It was to save the park at St. Helen's Island. At first I thought we got our point across because we made the papers in Montreal. I thought people would see what was going on and put a stop to the plans but they put an end to us demonstrating and went ahead and built Expo '67. Weird, I thought, to destroy nature to show off man's progress. When Expo was over and they didn't return the site to being a park, I knew that we had been standing in the way of people making money.

OUR RIGHTS ERODED IN THE 1990S

Walking along Bidwell Street in Vancouver not long ago, I saw Bill, my former boss. After exchanging greetings, I cut through the polite conversation and said, "Bill, we are losing all our rights. It's getting worse every day."

Bill nodded. "We busted our asses in the seventies to get our rights, and now the next generation is letting them slip away," he said. "They've moved to a different class and they don't care."

It doesn't happen very often anymore that someone like me, without professional qualifications, gets hired to do community work. After thirty years I'm still fighting for poor people's rights and speaking out so that their voices are heard. Here are a few true stories from my community.

Joanne is a single mom who has severe arthritis. She works part time and is subsidized by welfare. She used to be allowed to keep $200 of her earnings per month and she used this to put her two children in martial arts classes and to get bus passes. Now everything except 25 percent of her earnings is deducted from her welfare cheque. She wants to work but it costs her bus fare and childcare expenses. If 75 percent of her earnings are

deducted, her job is a drain on the family's finances. The kids have had to drop out of their karate classes, resulting in one frustrated mother and two unhappy kids. To Joanne it seems that the government doesn't want her to work, they don't want her kids to have a normal life. Why would they punish a poor single mom who was trying to provide for her family?

The percentage of single mothers under 25 living below the poverty line: 83 percent. "Poverty line" is a term used by social justice groups for what is officially called "low income cut-offs," an income level set by the government. People whose income is below this amount, which varies by location and size of family, are spending "disproportionate amounts" of money for food, shelter and clothing. In plain language, they are living in poverty. — Poverty Profile 1995

Joan was badly abused as a child: raped, beaten and bruised. When I got to know her as an adult she had a mental illness which caused her to yell at people that she saw but others didn't. She was often homeless and often pregnant. Joan took whatever she could to cover the pain: street drugs, alcohol, prescription drugs. Many of her babies were badly damaged by her substance abuse. Some of them, I guess, will live their whole lives in institutions.

I have seen the damage that drugs and alcohol do to unborn babies. I don't know what the solution is. Feminists say a woman's body is her own. Christians say no abortions. Right-wing zealots say forced sterilization. Our governments say they will abolish child poverty by the year 2000, but surely I see no signs of that. Joan's damaged children never had a chance, and neither did she. Women like Joan end up in

prison or in mental institutions because our society doesn't take care of its children, especially if they are poor. As long as society accepts violence, pornography, child sexual abuse and hunger, there will be no end to child poverty. Until poor children are nurtured and loved equally, and until resources are provided for the whole family, there will be no change for the better.

In 1996, four of ten children—1.5 million children—lived in poverty in Canada. Child poverty has risen by 45 percent since 1989.

—NAC's *Voters' Guide*

Allison has two children, girls age six and nine. Even though she has a health problem, she works on contract in a daycare centre. Working on contract means no paid holidays (not even Christmas or Easter), no medical or dental plan, no sick pay. Her younger daughter, Sarah, has asthma and very bad allergies. Sarah got very sick with bronchitis shortly before Christmas. Allison couldn't take time off work because Christmas was coming and she would not be paid for the statutory holidays and that meant she would have problems paying the rent, let alone having any Christmas celebration. So Sarah kept going to school and became sicker. When she went to the doctor, he prescribed antibiotics and asthma medication that cost $90. The stress of not having any savings and having to find $90 to pay for her daughter's medicine aggravated Allison's Lupus disease. She had to take a couple of days off work. She managed to borrow the money for her daughter's medication, but what if she hadn't been able to? Where in this rich province would this small child have gotten life-saving medicine? Putting single parents to work is a great idea if there is good daycare and they get good wages and paid holidays. But Allison's story is more often how it really works.

I remember Kathy when she was about eight years old. She had cornflower-blue eyes and wispy brown hair and a freckled nose.

In 1995 single-parent mothers with children under 18 on average lived at $8,851 below the poverty line. Of these families, 75,000 lived on less than half of the poverty level income and an additional 157,000 had incomes between 50 and 75 percent of the poverty level.— Poverty Profile 1995

The thing she most wanted to do was to learn to play the piano. I remember her mom looking at me sadly, saying, "That costs money. What she needs is a new pair of runners. What she needs is fresh fruit."

Now Kathy is fifteen and her mom has two more children. Kathy never got piano lessons and she's not in school anymore, she's helping her mom with the babies. Last time I saw Kathy she had a diaper bag on her shoulder, a baby brother in her arms and another brother holding her hand. Her childhood is lost, and so are her dreams.

Less than 15 percent of children who need childcare have access to licensed care. —NAC, Shocking Pink Paper

I met up with Yvonne recently, a young mother with three small children. Her husband left town without providing any family support. She told me she hated asking for welfare; welfare is a dirty word for her because of all the headlines of welfare fraud, welfare bums. But she didn't have enough money to pay for her rent and electricity and phone bill. She felt a lot of shame when she was forced to go to the food bank, but she had no choice, her children had to eat. I encouraged Yvonne not to believe the images of poor people that the media portray. Poor people have rights. They benefit from advocacy, from joining up with others living in poverty and fighting back.

Of the estimated 323,000 poor single-parent mothers under 65 in 1995, only 23 percent received child or spousal support, and the average amount received was $3,745. —Poverty Profile 1995

I've known Wally since he was about four years old. I remember he used to hang onto his mother's skirt as she delivered political flyers. Raven, his mother, is a woman of Cree heritage who understands that poverty is political. She always encouraged his dreams and filled him with optimism that he would reach his goals. He quit school at a young age because, he said, "The kids called me Welfare Wally." But he always loved drumming and making music, and his mother saved and saved to get him a guitar. The community at the Carnegie Centre supported his talent and his interest in music. Because of his dream of recording music, he never got into drugs. "I am a musician, I need my brain," he told me. He started his own rock group and later was able to attend night school and then studied music and recording at college.

Last week I saw Raven on the Main Street bus and she told me Wally is twenty now and his group has put out a CD and is touring with it. I'm so proud of Wally. I think the reason he made it was because his mother understood the politics of poverty and retained her pride. I wish that knowledge were taught to all our working-class and poor children.

Between 1990 and 1995, the percentage of poor families with children under 18 rose from 23 percent to 35 percent.

—*Poverty Profile 1995*

I met Isabel on the Robson Street bus. She's a very thin woman with a tiny frame but at seventy-one she is full of energy and conversation. She has a bus pass so she travels right across Vancouver from the West End looking to save a few cents here and there on groceries. Today she was going to buy muffins three bus trips away—an hour and a half travelling to save forty-nine cents. She told me it was getting harder and harder to manage these long trips but she doesn't have the money to pay West End food prices.

The average income of a single Canadian woman under age 65 with no children was $8,271 in 1995. For older people, the maximum combined income from Old Age Security pension and Guaranteed Income Supplement was $10,264 for a single senior and $16,642 for senior couples. —Poverty Profile 1995

Coming home on the bus recently about 9:30 p.m., as we passed Granville Street near Davie I noticed a block-long line-up for food. All kinds of people, young and old, were sitting patiently on the Granville sidewalk, most with their heads held low, not looking at the tourists who were passing them by. Our bus driver was chatting to some nice average American tourists about late-night shopping on Robson Street and had they been to Stanley Park yet. "Vancouver is such a wonderful city," they said, not commenting on the food line.

Are the hungry like a pest problem? If you just don't mention it maybe it will go away? Or do you call the pest control office and remove the problem temporarily until the new eggs hatch and multiply and then no amount of spray will solve the problem?

As I walked past the McDonald's on Robson and Bidwell, I saw a man of about fifty with a tanned face and very worn clothes. He found half a cigarette and an ice cream sundae with some left in the container. He ate it with a big smile and put the half cigarette behind his ear. Sadness filled my heart. Tourists on rollerblades sped by, not seeing him.

With the government's decision to make people work for welfare, poor people will be called not only "welfare bums" but now also "welfare scabs." We will be replacing workers who may have a decent-paying job with our cheap labour. Then those workers will have no jobs and they will become welfare scabs forced to take away jobs from other people. The result is that corporations get a labour force of slaves whose pay cheques

Eroding our rights . . .

In 1996, the federal govenment got rid of the Canada Assistance Program (CAP) and replaced it with the Canada Health and Social Transfer (CHST).

Rights guaranteed under the Canada Assistance Program (CAP)

CAP became law in 1966 and although it did not eradicate poverty in Canada, it did bring these rights to everyone:
* *the right to social assistance when in need;*
* *the right to choose work, and not to be forced into work or training for welfare;*
* *the right to an adequate level of income;*
* *the right to appeal decisions that you don't agree with.*

Rights lost under the Canada Health and Social Transfer (CHST)

The CHST became law in 1996 and took away these rights. The CHST means less money for social programs, leading to increased poverty. It opens the door for even more poor-bashing and blaming the poor for the state of the economy. These are some of the changes:
* *No more national standards—the rights under CAP are gone.*
* *In the past, the federal government gave each province payments dedicated for specific social programs like welfare, Medicare and post-secondary education. Now each province receives a lump "transfer payment." The result has been dramatic cuts to social assistance across Canada and the introduction of new programs like workfare.*
* *Money for social programs is being cut. Transfer payments are being cut by $7 billion over three years. By the year 2000, cuts will total $11.1 billion.*
* *Workfare—forcing people to work at government-approved jobs or training programs in order to receive welfare—is being implemented in many provinces.*

—NAPO, Opening Our Doors; NAC's Voters' Guide

aren't even enough for rent, let alone food. If we are kept poor and hungry enough, we'll do whatever they want. Women will use our wombs as baby nests for the rich, we'll work in the sex trade in government-run houses, we'll sell our body parts for organ transplants. Is that government's idea of a level playing field?

Why not workfare?

- *It drives down wages and working conditions. Employers receive wage subsidies, making it cheaper to use welfare recipients than to hire full-time staff.*
- *Full-time workers with fair wages can lose their jobs and be replaced by people on workfare;*
- *Single mothers are being forced to work, leaving little time to care for their children;*
- *No one should be forced to work for unfair wages in a job they haven't chosen.*

— WHOA; NAC's *Voters' Guide*

An alternative to workfare . . .

There is another way: create jobs, create training programs for real jobs, value women's work in the home, take social responsibility for childcare, raise the minimum wage and improve labour standards.

—NAC, quoted in *Welfare Changes, Does B.C. Benefit?*

A reporter from a small local paper came to my apartment to interview me about my book *No Way to Live*. I was living in social housing on a handicapped pension, because of my disability. This guy looked around at my small, clean place, noticed I had an old colour TV and a cheap radio/cassette player, and said, "I can't accept that you are on welfare and you have this equipment."

My income at the time was $9,000 a year. What business of his is it how I manage to scrape by? I have food and shelter and money to buy coffee and sometimes something second-hand

materializes for me. Because of my knee replacement surgery I have a bus pass. That really makes a difference. I couldn't do my community work without it because I could never afford the bus fare. I like my life. True, there are things that money could buy that would make my life more pleasant, more interesting, but I don't think I would change my lifestyle if I wrote a best-seller!

Signs of Canada's economic ills . . .
In 1995, over five million adult Canadians lived on less than $10,000. In 1995, the combined profit of the one hundred largest companies was $65 billion. —NAPO, *Opening Our Doors*

Poor Am I

The eyes of a family that love me
Shine like priceless jewels
The little hands that hold mine
Are precious beyond measure
The green and purple mountains
Wrap me in their colours
The ocean, sparkling gems from
Sunbeams, splashes my eyes
My cat is my fur coat
That sheds on me.

If poor means not much money
Poor am I
Yet I'm rich in non-capitalist possessions:
Friends, hugs, birthday candles, picnics and sunsets.

NOTES

1 The shelter was named after Doris, a local prostitute who lived a difficult, troubled life on the streets of Montreal. She was brutally murdered in 1974. Her life and death symbolized the need for community services for poor women.

2 In 1980 the Canadian Human Rights Foundation commissioned Professor Aileen D. Ross of McGill University to undertake research on homeless women. Her report, *The Lost and the Lonely: Homeless Women in Montreal,* was based on participant observation of the women who used Chez Doris and Maison Marguerite, a women's night shelter also established in 1977. In her preface she writes: "The birth of Chez Doris and, incidentally, of Maison Marguerite was due mainly to Sheila Baxter, a community worker with Ville Marie Social Service Centre."

Activism and Community Problem-Solving

Activism Is My True Love?

Activism, fighting for rights,
What a great lover you have been.
Dependable, there's always a cause.
Injustice is an ever-running tap
Filling my days and nights
And rainy Sunday afternoons.

Winning an Action is my giant "O"
Dearest Activism how you have filled
My soul, my brain, my body.
Yet if I had stopped for a brief moment
Long enough to listen
To my aching heart
I would have known,
I would have known a real lover.

As a community organizer and activist around many issues I've used a simple formula that has been successful for me: first, I do the research in the community, identifying the needs. Then I involve people who have the skills I don't have. I'm honest about my own strengths and weaknesses, and I look for people whose expertise can help the cause. My recipe for success as an organizer is having a vision, sharing the power and being non-controlling. My major philosophy is that if you're building a movement—no matter what movement—you have to love each person. In any group that I've worked in, my experience is that

if you love and hug and care about each person then you have a strong foundation in the group. You can't say, "It's the movement that counts; the individual doesn't." Each person is precious, and you have to build from the ground up.

Social movements that last are built both by educating people politically and through friendship, support and nurturing on an individual basis. If winning an issue, getting media attention, getting a large turnout for an event are all that count, the people we are fighting for/with may end up feeling as powerless and abandoned as before the organizers came into the community. If we don't take the time to listen to individual people's pain and to ask them if they ate today, we're not helping them feel empowered.

The majority of advocates in the anti-poverty movement of the 1970s were on welfare and did the organizing work as volunteers. That's why we had a big movement. When advocacy became a government-paid job, the movement suffered. How can you fight the ones who issue your pay cheque? If government grants hadn't become available, poor people would have kept their power and I'm sure the movement would have grown even more.

To give a few people some money does not help others to stand up to the system. Advocates must empower people, not just do work for them. I have seen people empowered when someone takes the time to listen to their ideas and let those with problems offer their own solutions. If nothing changes for people personally, they will not become politicized. We need more of us doing the organizing, grassroots people who support each other.

Recently I spoke briefly at a rally at Canada Place that was against a global investment treaty. I took a tattered dishcloth with me and wrote slogans on it with a permanent marker. When I spoke I said that we have to start organizing again in people's kitchens. People in the audience liked that idea. I suggested we could all carry dishcloths with slogans and whip them out of our pockets, flaunting them. It doesn't cost much and the dishcloths are recycled into peaceful weapons. I had a vision of a billion dishcloths side by side, as we take back our power.

- *Number of people in Canada seeking work in 1996: 1.5 million.*
- *Number of jobs created in Canada in 1996: 186,000*
- *Number of families affected by unemployment in 1996: 1 out of 3.*
- *Percentage of Canadians who think they could lose their jobs in the next couple of years: 44 percent.* —NAPO, *Opening Our Doors*

Over the years as a community worker/activist, both volunteer and paid, I've learned what works and what fails. It seems that whenever a new group starts around an issue, a need, their conversations quickly start to centre around their wants. Where will we get a phone? a computer? a fax? office/staff/salaries? What colour will our stationery be? Who is in charge? How can we avoid biting the hand that feeds us, that of the government? Don't let Sally be a spokesperson, she's too radical. Don't let Marie go, she can't speak the language of the bureaucrats. The issue the group formed to address becomes the issue nobody ever talks about.

When funding sources shut down, so do movements, if we are funding-based. A fax machine and a computer are tools that cost money, yes, but of what use are they if the group falls apart and there is no one left to use them?

The poverty gap . . .
- *The income needed to bring all Canadians above the poverty line (in 1995): $16.3 billion.*
- *Deferred corporate taxes in Canada (1995): $37 billion.*
- *After-tax profits of Canada's top five banks (1995): $6 billion.*

—*Poverty Profile 1995* and NAPO*news*

I once started a Poor People's Paper in Montreal. I encouraged people to write small poems and thoughts and to draw cartoons. Most of the writers had a low level of education, so we kept the writing simple and the production costs down. Then a professional organizer came along and said the paper wasn't political enough. He took to writing long-winded articles full of

jargon. The poor folks stopped writing in the paper and in fact they stopped reading it. So what works is giving people their own paper, giving them the power.

The key to empowering poor people is for them to act on their own issues. A paid organizer can show the way but then must step back and encourage growth by allowing leadership to develop within the group. The goal of a community organizer must be to work themselves out of a job.

In the 1970s we used videos as an organizing tool. We filmed our demos and speeches and then got together to evaluate how we did. We also learned from "how to" videos: "How to hold a press conference," "How to resist peacefully," "How to identify a power monster in your group." This last one was particularly important because usually there is at least one power monster in every group. That person has perhaps never had any power in his or her life. When they join a group and are given a little power, they quickly get hooked and want more and more. They volunteer for every position and do more work than anyone else, all the while complaining, "I do everything around here." They make sure no one else learns what they know and often create fights with any new people who threaten their power. Although power monsters work hard, eventually the group has no choice but to displace them because they will destroy the group. Sharing the power, the knowledge and the work is crucial for the success of community groups organizing for change.

THE GRASSROOTERS

The anti-poverty movement of the 1970s grew out of kitchen meetings, mostly held by working-class people like myself. Parents with children who couldn't get out much enjoyed meeting with neighbours over coffee, talking about issues while the kids fought and played around the table.

Last year when I couldn't get around much because of poor health (I was diagnosed with Graves disease in my sixties), I

invited some people to a kitchen meeting at my house. We developed a loose support group and called ourselves The Grassrooters. We didn't need money and nobody had to do anything they didn't want to do. We want to stay loosely organized, nurturing each other and finding issues that we support. When the Gay Pride parade took place in the West End of Vancouver, there we were in the rain with balloons, chanting "Grassrooters Support Gay Rights." We also supported the Mole Hill community's fight to save low-cost housing.

We haven't grown very large, but our ages range from five to eighty and we support and nurture each other. Caring about each other as individuals is as important as organizing around community issues. And we must educate our children to be activists. Hooking up with unions is important—unity is power—but only when it is controlled *from the bottom up*.

An hour of business and then an hour of socializing—that's how we structure it. We have a rotating co-ordinator for the meetings and we all bring munchies to share. We use a notebook to keep minutes that are read at each meeting. When some members moved away, I thought the group would fold, but then someone called another meeting and so we continue. When you can no longer march with the marchers you can easily feel left behind, but there is still a need to come together around issues that you care about.

> **Disparities abound . . .**
> - *In 1995, the average provincial minimum wage in Canada was $5.46 per hour.*
> - *In 1995, the average pay rate for the CEOs of the one hundred largest companies was $638.01 per hour.*
>
> —NAPO, *Opening Our Doors*

I was at a demo recently in the square at the back of the Vancouver Art Gallery. It was organized by welfare workers to protest their heavy case loads and the number of job layoffs. People from the

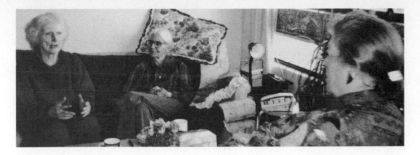

(*l. to r.*) Pat McCreery, Doris Rands and Marlene Baker at a Grassrooters' meeting at Sheila's Vancouver apartment.

anti-poverty movement joined in the demo because this is an issue where we can stand united. The cutbacks mean even fewer services for poor people, whose needs have hardly ever been met.

It was a windy, rain-soaked day. My umbrella kept turning inside-out from the brisk wind, but it felt good to be out there yelling and waving placards. I sometimes think this area has been designated as a playpen for activists. The powers-that-be probably have video cameras installed so they can watch who is saying what, who is doing what. All the important businessmen go by on their way to lunch, seldom paying us any attention. We're not a threat; we're just activists demonstrating in our playpen. Tourism B.C. loves our demos because the tour buses stop for photo shoots of democracy in action! I have this fantasy that someone will get a paid government job co-ordinating demos around prime tourist times.

Less to live on . . .

Social assistance is being cut cut cut across Canada. Eight percent in B.C., 13 percent in Alberta, 10 percent in Manitoba, 21.6 percent in Ontario. These are only some examples. —NAC's *Voters' Guide*

"All of these cuts fall hardest on aboriginal women, immigrant women, women of colour, and poor women."

—VSW activist, quoted in *Welfare Changes, Does B.C. Benefit?*

WOMEN'S MARCH

This is the sixth year that we have come together to mourn the violent deaths of women in the Downtown Eastside. As usual, we met at the Carnegie Centre. I brought a strong cane with me because I wanted to do the whole walk this time, even if it meant taking painkillers.

The theatre was packed with friends and relatives of the dead. Many of those present were Native, and I was really pleased that it was Native women who organized and conducted the march. No long-winded speeches here, just honest talk, Native prayers and smudging. The Native woman who MC'd the event was presented with a blanket, a gift of respect. Her message of wisdom made me regret again that my race, the white race, had tried to destroy the Native nations. I am not responsible for past crimes, but my race was, and it brings sad thoughts to my mind.

We assembled outside Carnegie with banners carrying the names of the women who had died. We were loud and visible and held up the traffic (not like at demos at Robson Square). Native women led the march and drummers brought up the back. Of course I walked the slowest and ended up at the back of the march, but the sounds of the drums and the power of the women kept me going.

We finished up demonstrating on the steps of the police station and then congregated at Oppenheimer Park, which is in the middle of the sex and drug trade district. We circled the whole park and lit white candles, two hundred or more candles in the rain and the mud. There were more prayers, dancing, drumming and smudging. Finally we moved to a nearby hall, where the smell of bannock and chili greeted us. I ached all over and had reached my limit of painkillers for the day. The Native Elders invited me to join them at their table and it was an honour to sit with them and share their company.

As I think ahead to next year, I wish there would be no more deaths and no need to hold a Women's March, but somehow the

reality is that women will keep being murdered. It's important to remember them, to mourn and to rage.

UNDER ATTACK: THE POLITICS OF POOR-BASHING

Early in 1995 I was invited to give a reading at a conference about poverty put on at the Langley Legal Assistance Centre. The highlight for me was reading together with a man from the Fraser Institute. I've been told that my books are at one end of the spectrum and the right-wing Fraser Institute's books are at the other end. Given their millions of dollars in revenue and my meagre earnings, there's a big difference in financial clout. One of their senior policy analysts had written a paper about a new approach to the welfare system. At the conference he gave a boring, long-winded talk that made me and some others in the audience very angry. I suggested to him that one way single parents could get off welfare would be if they got paid as economic analysts who would study the rich. He responded with a nervous laugh.

I told him my books about poverty are much more accurate than anything the Fraser Institute produces. To right-wing policy-makers the poor are dispensable. Take away our health care and we'll just die faster. Treat us like horses: if we break a leg or get sick, shoot us. If we get old, sell our bodies to the glue factory. The old and the sick can't work so they are not worth giving food and shelter to. That's the kind of thinking we're up against.

"Social programs didn't create the federal debt. Statistics Canada reports that only 2 percent of the debt can be attributed to spending on social programs, while 50 percent is due to high interest rate policies [in effect until recently] and 44 percent is the result of tax breaks to corporations and upper-income earners."
—*Standing on Guard for Canada's Social Programs*

Most politicians, be they right-wing, left-wing or centre, use poor-bashing to get votes. Poor people are used as scapegoats for all of society's economic problems and to divert anger away from the greed of rich people and of corporations and banks which get millions of dollars in tax breaks from the government. Stern-faced politicians face TV cameras and point the finger at poor people, saying no more welfare fraud, no more lazing around on welfare, no more free rides for people who don't want to work, no more free money for drug addicts and alcoholics. The media play up dysfunctional alcoholics and drug users as the typical poor person, yet thousands and thousands of unemployed non-substance-abusers struggle to feed their families. They quietly line up at food banks, hanging their heads in shame for being poor. I've been called a "free rider" because my income is too low to pay income tax. I am guilty of being poor; does this mean I don't deserve to be alive?

I hate this. Maybe I should just leave it there. I will not let this fact-distorting, sensationalist newspaper upset me! AARRRGH!!

A satirical response to the welfare bashers

"Corporate fraud artists rip off $2 billion," says the headline in the June 1996 *The Long Haul*, published monthly in Vancouver by End Legislated Poverty. The article reported that $2 billion had been fraudulently claimed under the Scientific Research Tax Credit by firms that never lived up to their research promises. Revenue Canada apparently had given up trying to recoup these tax losses. But did anyone see TV stories about these rip-offs? Did talk show hosts trash corporations as

liars, cheats, fraud artists or deadbeats? Did anyone suggest fingerprinting corporate executives who claim tax credits? Did politicians call for a crackdown on corporate fraud? That's what has happened in the past when people on welfare have merely been accused of welfare fraud, not even convicted, as some of these corporations were.

A new trend in poor-bashing is to use the language of the recovery movement to talk about how people can get "addicted to welfare" and become "chronic users," and how welfare "creates dependency." According to poor-bashers, the only people who should receive help are those they consider the "deserving poor"— people who are missing arms or legs or eyes or perhaps dying from a socially acceptable disease.

> The "official" unemployment rate now hovers around 10 percent. The "unofficial" unemployment rate—which includes "underemployed" people working part time who would rather be working full time, people on income assistance who want employment, and people who have simply given up finding a job—is estimated at 15 percent.
> —NAPO, *Opening Our Doors*

The truth about poor people is very different from the lies perpetuated by the politicians and the media. When we get our welfare cheques, we pay our bills and we buy food and clothing, often walking or travelling by bus around the city to get the best bargains. We stock up on day-old bread and food "specials," toilet paper, soap, diapers and second-hand clothes. It's almost impossible to live on the money that current welfare rates provide, especially if you have children. Thrift stores are packed with mothers desperately searching for a pair of runners that may fit their child. When the kids are young it's easier to find second-hand clothing but when they get to be teens, it's very frustrating and depressing for parents who are trying to stretch the few dollars they have for clothing. The teenagers want to

The number of women who work at more than one job has increased 372 percent over the past twenty years. Part-time workers are 70 percent women; 33 percent of them would prefer to have full-time paid work. —NAC's Voters' Guide; CLC, *Am I Missing Something Here?*

dress like the others kids in school, they want to wear what's "in" right now, not cast-offs from several years ago.

Like other parents, poor people love their children and want the best for them. But kids are tormented at school for being poor. Many children that I interviewed for my book *A Child Is Not a Toy* talked about the pain and shame of being called welfare kid, welfare bum. Kids are shamed into quitting school—that's one of the outcomes of poor-bashing. Sometimes parents get desperate enough to have their kids put into foster care because they believe they will be better off there.

Mothers treated like criminals . . .
"I think there has to be a real understanding that mothers contribute. We get criminalized or treated like criminals because we happen to be raising children and we don't have a husband."
—single mother on welfare, quoted in *Welfare Changes, Does B.C. Benefit?*

There are things we can all do to end poor-bashing. We can write letters to politicians and challenge them at public meetings when they stereotype people who are poor. Many voters are ignorant about the true causes of poverty and the actual lives of poor people. The media blame poor people for the state of the economy, but there is no factual basis for doing so. Welfare scams are not the real reason why taxes are so high. Corporate tax evasion, government perks and huge bank profits contribute much more to the deficit and the high taxes.

Poor-bashing is discrimination the same as racism and sexism—it's using and abusing people's poverty. Encourage your church, your union, your neighbours to write letters to the media

when they see poor-bashing. Don't buy the lie that tax dollars are being wasted on poor people. That's just scapegoating, diverting people's attention from the real causes of economic hardship.

Join in resisting . . .

End Legislated Poverty (ELP) is a provincial coalition of groups in British Columbia representing churches, women, unions and people with disabilities. Its aim is to educate on the need to end poverty and create decent jobs, and to organize low-income people who are paid and unpaid. For information about ELP, write to 211 - 456 West Broadway, Vancouver, B.C. V5Y 1R3

The National Anti-Poverty Organization (NAPO) is a non-profit organization established in 1971 to represent the interests of low-income Canadians. It advocates on their behalf at the national level and supports similar provincial/territorial and local groups. For information about NAPO write to 440 - 325 Dalhousie Street, Ottawa, Ontario K1N 7G2

They call themselves binners or dumpster divers. They are the legion of Downtown Eastsiders who troll the back alleys and dumpsters of Vancouver's lowest-income neighborhood, looking for empty pop bottles and beer cans they can recycle into spare change. About 350 regular binners turned in six million bottles and cans this year [1996] to a non-profit recycling depot on Cordova Street. At a nickel a container, they earned an average of $4.50 per visit.

—*Vancouver Sun,* 24 December 1996

A friend introduced me to a man who is a dumpster diver: he finds things, fixes them and sells them. When he does his dumpster route he takes his elderly mother with him. She is quite small, so he lifts her up and puts her into the dumpster, and she passes him the stuff.

There is an underground industry evolving around dumpsters, and people work really hard at it. Recently at 9:30 in the morning I counted thirty people lined up to recycle cans they had dug out of the garbage. Tired-looking, hungry, dirty from digging, they earned a few dollars for food. Being poor is hard work.

Harvest for Whom

Throw it away if they can't pay
Dictates the market economy
Flush that milk down the drain
Excess is bad for the market
Plough that food back into the soil
We must keep up the prices.

Older folks can't afford butter
Families go without milk
Children go hungry to school
But throw it away
If they can't pay
Can the poor thank God for the harvest?

Nowhere for Nobody: Housing Needs and Homelessness

"Hotel found unfit for human occupancy," says the headline. "Lack of working toilets, human waste and blood all over the floor . . . There are cockroaches and mice. Many of the rooms don't even have a mattress."[1]

This isn't a headline from 19th-century England. It's June 1997 in beautiful British Columbia. Unfortunately this isn't an isolated incident. For several decades, single room occupancy (SRO) hotels have housed Vancouver's poorest residents: people living on social assistance and seniors living in poverty. The rooms average ten by twelve feet, many have only a hot plate for cooking, often the doors have no locks and the communal washrooms are unclean. What the city health inspector found at the 45-room Roosevelt Hotel in Vancouver's Downtown Eastside is simply a little worse than the conditions many people live with for years.

SROs were never intended to be a solution for homelessness, but for many poor people they are the only option. When the city tries to enforce safety and decent living standards, the hotel owners threaten to close the buildings. Housing activists fight to preserve SROs because they are an alternative to absolute homelessness. In recent years, an increasing number of people with "special needs"—physical disabilities, mental illness, drug or alcohol problems, or HIV/AIDS—have been forced to live in SROs.

Over one million Canadians are in need of affordable housing.

—NAC, *Shocking Pink Paper*

Over 40 percent of single women aged 65+ and 20 percent of single men aged 65+ lived in poverty in 1995.

—*1997 Seniors Election Handbook*

Over half of all the low-income housing units in the Downtown Eastside are in residential hotels and rooming houses. What helps the long-term residents get by are services for low-income earners in the local area, such as free food services, the Carnegie Community Centre and CRAB Park. Many of the SRO buildings are old and have been allowed to deteriorate. The small, shabby rooms that poor people could afford are coming under the wreckers' ball throughout the downtown area. As one man said to me recently, pretty soon there won't be nowhere for nobody.

When the hotels are renovated, often they are upgraded to accommodate tourists and travellers, making former long-term residents homeless. In other cases the old hotels are demolished and replaced by new developments for higher income residents. In one two-block area in the Downtown Eastside, SRO hotels that housed two thousand are being turned into condominiums, with an international shopping village being developed nearby.

They're caught in a vise—and it's starting to hurt. Residents of Canada's lowest-income neighborhood are being squeezed by newcomers from two different directions at the same time, sparking fears that the survival of their community is at stake. It's an ironic predicament for Vancouver's Downtown Eastside. While an increase in street crime is driving down the quality of life of residents, a surge of upscale condo developments is threatening to inflate property values and price the old-timers out of their low-rent hotels.

— *Vancouver Sun*, 14 February 1995

As of 1996, nearly half of all the SRO hotel units in the Downtown Eastside and Granville Street neighbourhoods charged rent that was higher than what people on social assistance received for shelter (shelter allowance in British Columbia in 1996 was $325 per month for a single adult). This forces hotel residents to take money from their basic allowance and use it for rent, which for most people means living on less than $6 a day.

The guidelines for getting financial crisis grants in British Columbia have been severely tightened, with a reduction of 32 percent in the number of such grants given in the first year after cuts to social services were introduced in 1995. —Welfare Changes, Does B.C. Benefit?

Billy was twenty-seven, a young man from Nova Scotia. He had lived in foster homes since his mother disappeared when he was six. He knew no father, no other family. Here in Vancouver he worked at construction and various low-paying jobs. His spirits were low. He had hoped to find his mother in Vancouver; someone had said a long time ago that she had run away with a train porter and headed west.

Billy was slight, maybe 5'7", with brown eyes and straight black hair. He liked to play the mouth organ. He would join his street friends and share a bottle of cheap wine that they had panhandled for.

One really cold November night Billy was sitting with his friends in one of the back lanes off Hastings Street. It was raining hard. It had been raining for days, and everyone was damp and cold. After a while, his friends left to try and get into a shelter for the night. Billy said he'd see them later.

About a week later Billy's body was found hanging from a piece of machinery at the dump. His friends figured that he had climbed into a dumpster for shelter from the rain and fallen asleep there. When the big garbage truck came along, its mechanical arm swung out, lifted the dumpster with Billy in it and compressed him with all the garbage. If his twisted, broken body hadn't gotten stuck on a piece of equipment, no one would have known where he had gone or how he died.

Imagine . . .

. . . living on $260 a month. This is the welfare rate for a single "employable" person in New Brunswick.

—NAC's *Voters' Guide*

WOODWARD'S: MORE THAN A BUILDING

Woodward's department store opened on Hastings Street in Downtown Eastside Vancouver in 1903, and remained open until 1993. The food floor in the basement of Woodward's was an important social centre for neighbourhood people. The coffee shop was a gathering place and the store took bottle and can returns and was a primary food store in the area.

When Woodward's closed, it was a major loss to the community. No more $1.49 days, where you could stock up on shampoo and toilet paper and sit for hours over a coffee visiting with your friends. No more Christmastime visits with my grandchildren to the delightful winter wonderlands of mice on ice and bears baking bread, free suckers and colouring books from Santa. Since the closing of Woodward's, all the stores where I used to shop for bargains are gone. FEDCO, a family discount clothing store, is boarded up and the Sears bargain floor has been replaced by the downtown campus of Simon Fraser University. There are so many empty stores along Hastings Street that the area looks like a ghost town.

DERA, the Downtown Eastside Residents' Association, is a community-directed, charitable society formed in 1973 by residents of the poorest urban neighbourhood in Canada. Fighting homelessness and poverty is DERA's primary focus.

"Woodward's wannabe developers will be at the DERA General Meeting Thursday April 20," announced the April 1995 DERA *Newsletter*: "Be there to have your say on development for the rich at the expense of the poor!"

A developer, Fama Holdings Ltd., had bought the old Woodward's building and was planning to build retail boutiques and condos with lofts. Their proposal was to build 350 condos selling for $150,000 to $200,000 each. Several years earlier,

Looking like a ghost town, a strip along Hastings Street is dominated by boarded-up buildings.

DERA had put forward a proposal to create housing (both market and social housing units), a food floor, childcare facilities, and a community recreational centre in the Woodward's building. The goal was to turn it again into a central gathering and meeting place for people in the community. Unfortunately neither the provincial nor the federal government provided the necessary funding for this social housing project.

When Fama announced its plans, business owners in nearby Gastown spoke out in support of the development. The *Gastown Tribune* wrote: "Fama Holdings, a reputable developer, is coming to Vancouver's rescue. Of course, we are welcoming the plans with open arms as this means revitalizing a very important part of our city . . . This is exactly the kind of project we need here."

The April *Carnegie Newsletter* told the other side of the story: "A development like this one will start pushing out all the low income housing for blocks around it. Property values will start to increase. Building owners all over that part of the Downtown Eastside will get ready to redevelop their properties into something that fits in with the yuppie lifestyle . . . We are being invited to give up and buy in. Let's stand up and speak out."

On May 7th, over a hundred Downtown Eastsiders of all ages gathered to clean up and beautify the street-level windows of the Woodward's building. Lots of kids joined in, as well as parents and older people, all scrubbing the windows and sweeping the sidewalk. Then we painted all the windows with flowers and kids' art and slogans about saving our community. The developer washed our art off the windows a few times, but over the summer of 1995 the Carnegie community organized several such actions to show the developers that local residents considered the building theirs and had plans of their own for its future use. The series of window-painting parties brought media attention to the fact that long-time local residents feared losing their housing as a result of "condo mania."

Local residents painted the windows at the Woodward's building in bright blue, green, yellow and orange designs, demonstrating the community's interest in keeping it accessible.

Margaret is a Native woman who uses a wheelchair but is always out there participating in the Downtown Eastside community, even painting a window at Woodward's. The day she and I were there painting, a representative of Fama came by. He had a small boy about three years old with him and they were watching me write "No condominiums. Children need houses." The little boy said, "Daddy, I want to paint!" I looked at him and said, "I have eight grandchildren, some around your age. Would you like to paint a flower on this window?" I handed him a brush with red paint and he painted a beautiful flower under my slogan. "Why don't you give it up and come over to our side, do something that you will be proud of?" I asked the developer. Maybe it was my imagination, but I thought I saw a little sadness in his eyes. He is going to have to explain all this to his child someday. I wonder what he'll say.

> The combined wealth of the richest fifty Canadians—close to $39 billion—would be nearly enough to pay off the entire federal deficit. . . . The Fraser Institute, a right-wing think tank which influences the media and the government, is designated as a charitable organization so corporations and individuals can write off any donations to it, just like they write off donations to food banks.
>
> —*The Long Haul*, April 1996

The window I painted at Woodward's is on the corner of Hastings and Abbott Streets. For a long time an elderly black woman sat out on the sidewalk at that corner, shouting gospel messages in a very loud voice. Usually I avoid people that scream at me about getting saved because I believe that it's international corporations that I need saving from. But recently I stopped and went up to her because she was sitting right under "my" window, screaming "Praise the Lord." She sat on a garden chair, handing out grubby-looking literature with one hand and holding a can for donations in her other hand.

"Hi, how long have you been here?" I asked her. Huge brown

eyes smiled at me from under the broad-rimmed hat that framed her hair.

"Ten years or more, Praise the Lord, and I'll stay until my Maker comes for me, Praise the Lord."

"But what if they pull the store down?"

"No way, no way. They gonna build condos and housing for the poor here."

"Are you sure?" I asked.

"Yes, I'm sure, Praise the Lord."

"So your Lord is gonna make sure we get that housing for the poor, huh?"

"Yes ma'am." She broke into a strong hymn to praise the Lord, and I could still hear her when I was two blocks away.

In November 1995 Premier Mike Harcourt announced that he was committed to ensuring one-third social housing units in the Woodward's building. The City of Vancouver, the Provincial government, Fama Holdings and a representative of the Downtown Eastside community, Jim Green, began negotiations to make it happen. In December, the city promised to put $1.1 million into Woodward's for low-income suites.

It looked like another victory for the Downtown Eastside community: a significant amount of new housing at welfare shelter rates was on the horizon. In November 1996 the *Carnegie Newsletter* reported: "Our dream is now . . . the Woodward's Co-op is real. The Co-op will begin to develop a waitlist during the Spring of 1997. We hope move-in will take place around Christmas of '98." The February 15, 1997 *Carnegie Newsletter* announced a victory celebration: "We have fought for years to save the Woodward's building. Now we have it, and it is time to celebrate. . . . With full community involvement, Woodward's will become a model of urban revitalization that everyone can be proud of."

In April 1997, the Woodward's housing deal collapsed. Fama Holdings Ltd. announced that it was dropping plans to include 200 co-op housing units in its 400-unit project because too many issues remained unresolved with the provincial government. It was a major setback for the Downtown Eastside community, but activists immediately mobilized protests and began lobbying to ensure that the money earmarked for social housing would not vanish. The fight for the Woodward's building is part of an ongoing fight for affordable housing and to save poor people's neighbourhoods. Until poor people have equal rights to stay living in their communities, there will be no social justice.

Canada ranked No. 1. . .

According to the 1997 UN Human Development Report (based on 1994 data), Canada is the best country in the world to live in. What the figures don't reveal is that the distribution of income is becoming less equitable. A 1996 study by the Canadian Council on Social Development found that employment income for the poorest 20 percent of Canadians dropped by one-third between 1984 and 1994.

Where I live, in the West End, whole neighbourhoods are disappearing, bulldozed to the ground and replaced with leaky, poorly made condominiums. On the corner of my street, all the little stores have been given unexpected lease terminations. The small store where I used to buy bread and milk, the beautiful plant and flower shop, the Middle Eastern store with its strong, sweet spices, and the old-fashioned hardware store where the man who runs it used to give me all the time I needed to choose just the right colour of paint. It was nice to shop in stores where the owners recognized me. What will replace them? More pricey Starbucks coffee bars and expensive boutiques?

The federal government is no longer funding any new social housing or housing co-ops, and the provincial government has a very limited budget for social housing. As Vancouver continues

to be under attack from developers, homelessness becomes an increasing problem.

Say that again . . .

"We commit ourselves to the goal of eradicating poverty in the world through decisive national actions and international coopera- tion, as an ethical, social, political and economic imperative of humankind."

—Declaration signed by Canada in March 1995 at the World Summit on Social Development.

One in six people in Canada lived in poverty in 1996.

—NAC's *Voters' Guide*

At the corner of Bidwell and Haro Streets in the West End of Vancouver, there is a shopping cart covered with plastic bags and piled six feet high with paint cans and plastic pails. It could pass as leftover garbage from a construction site, which is what I think it is at first. Then I see her, barely, in the dusk. She is standing against a high prickly hedge, her possessions protected a little by a huge old chestnut tree.

As I get closer, I can see she is a small woman, skinny and fragile-looking, maybe about sixty years old. I think she might be the woman I had seen all summer sleeping in the doorway of my neighbourhood 7-Eleven store. Whoever she is, she has taken up residence on my street.

I say hi, but she doesn't really respond, just seems to be talking to herself. It is unusually cold for this time of year in Vancouver, snowing in fact, and I can see that she is soaking wet. She wears running shoes with no socks, and for a brief moment I remember my own childhood of poverty, when my feet were sockless in the winter and my shoes were wet. I ask her if she is cold. "No! No!" she says. I see that her nose is running. She obviously isn't well. "I was out for a while today. I may go out again later," she says. She talks as if we are neighbours standing in our back yards.

I go home and cry, thinking about her. From my window I can see the tree that shelters her, but not her. Finally I decide to call 911. I tell them that there is an old woman sleeping outside, that she needs a warm shelter or she could freeze on the street tonight. The dispatcher tells me they will send someone.

After about half an hour of watching out my window, I see the police arrive. I watch as they talk to her for twenty minutes, then leave. It is dark by now, and strong winds are forecast overnight. I get dressed and go back out onto the street. I go up to the woman's cart, her home, but I can't see her. She is probably down for the night under all her bags. There is nothing to knock on, so I yell that strong winds are coming. I say it a few times, but there is no reply. I observe that her belongings are all securely tied down. Maybe she has heard about the storm.

The next morning I see that the woman has moved to a small block on Barclay at Bidwell. Now she is easily visible from my window. It is so cold. I look up at the mountains, and they are all peaked with snow. I take a heavy wool sweater from my closet and walk the short distance to her home.

The woman is sitting on a yellow milk crate, bent over, with her face down. I say hi. As she looks up, I see that she is wearing a wig, and she has a black hat pulled down over her ears. Her face is white, with several scabs on it. She has beautiful eyes. Again she wears no socks. I offer her the sweater, but she refuses.

"It will keep you warm," I say. "You should be wearing socks too, you know. I could get you some."

"No," she says very firmly. "No. I never wear socks."

"Do you need anything else?" I ask. "Can I bring you some food?"

"No, no," she says again. "A woman from over there"—she gestures at an apartment building across the street—"she brought me some food, but I prefer to eat my own."

"Well, at least you are beside the community centre," I say. "You are close to the washrooms."

"Oh no," she says. "I have my own." She points to one of the plastic buckets in her cart.

She asks me how old I think she is. Fifty or sixty, I guess. "I am a thousand years old," she replies. "I have been around for a thousand years." Somehow I almost believe her. "I had a house once. That's the only thing I'd live in, a house."

The smell of dried urine starts to get to me, so I step back a little. In Montreal, I remember, homeless women would deliberately allow themselves to smell bad to protect themselves from getting raped. "You were on Haro Street yesterday. I talked to you there," I say.

"I was there for Halloween but the police came and told me to move on," she says. "I like it here, though."

I realize that my calling 911 hadn't helped her. In fact, it had made her life even more difficult. I feel guilty. "My name's Sheila," I say. "I live over there. What's your name?"

"Linda," she says. "I'm from Manitoba. I'm a thousand years old." We chat a bit more, then she goes off into her mind, talking away about things that only she can understand.

"Bye then," I say. "Take care."

I go back to my warm apartment, wondering how she will survive. There is no one I can call to help her. They will just move her on.

I spend that night at my daughter's place. When I come back in the morning, I look out my window. The woman is gone, and I feel sad. She has not left one bag behind. I hope she is somewhere safe.

Developer offers cash in lieu of social housing

City staff present a report today recommending that Vancouver council accept up to $1.6 million from Concord Pacific in exchange for an exemption from its commitment to help pay for 150 units of social housing in a development on False Creek's north shore. —*Vancouver Sun*, 13 May 1997

According to the corporate agenda, poor people have no right to community. The corporate agenda is, "We want your space. We're gong to pull down your housing and build condos. You have no rights. Just move out and move on."

They expect poor people to go quietly into the night, to quietly disappear or quietly starve to death in a corner somewhere. Well, I've got news for them. If they keep on destroying housing, there are going to be more robberies, more murders, more drugs, and more sex trade. That's all going to increase because poor people have no options. If there's nowhere to rent that's under $1,000 then people have to sell drugs, steal or do something because minimum wage work won't provide that amount of money for rent. It's forcing people into crime. If you've got no choice but to commit a crime to put a roof over your head, should you go quietly and die, or should you steal?

Where I live, in the West End, you can't rent unless you have megabucks. There's just nowhere to rent if you're low income. It's scary. I'm one of the few lucky enough to be in social housing. People stay sane when they have a community. You have a community and you have support, someone to babysit your kids, someone to talk to when you're sad, someone to hang out with. When people are scattered, they have no community. I think it creates a lot of conditions of depression, especially in older people. But where is there to go? First families double up, children move back in with their parents. Soon you'll have a whole lot of people sleeping in the streets and going to homeless shelters. Poor people are being squished out of our communities. The condos are like mushrooms: they pop up overnight. Often they are poorly constructed and leak water, creating huge repair problems once people are living in them.

Shortly after fall arrived last year, a homeless woman came to stay beside the 7-Eleven around the corner from my apartment building. She is a strong, tall, heavy-set woman with blue eyes in a reddened face. Her shopping cart is piled high with flattened

At the end of 1996, a total of 5.2 million—or one in six—people in Canada lived in poverty. —Statistics Canada

boxes. I talk to her when she allows me to. She tells me her name is June. One day she shows me her hand. Her knuckles, already swollen and twisted, are covered with scabs and bruises.

"What happened?" I ask, shocked.

She replies in a very calm voice. "It's those teenagers, you know. They came after me in the park." She motions with her head to the tennis courts on Bidwell and Barclay. "They hit my hand with a gun, and kept hitting it. Now it hurts when I get up and down."

"You should get it fixed," I say. She gives me a look and moves away.

She spends all winter sleeping under her boxes in the parking lot. She has at least a dozen plastic bags wrapped around her feet and her head, and layers and layers of clothing. I see her getting a drink at the Robson market and using the washrooms there.

June wanders up and down Robson Street, oblivious to the stares she attracts. She seems to be window-shopping. I don't know how she manages to push her heavy cart up the hills. I respect her survival skills and admire her ability to do what she wants regardless of what people think.

One day I see her while I am waiting for a bus. It is a sunny February day with a promise of spring, but the nights are still freezing cold. She has the usual plastic bags around her feet.

"You've made it through another winter," I say. "A really cold one."

She nods and looks into my eyes, checking me out. "If you see my boots on a woman called Pearl, tell her I need them. She stole them from me. They are brown."

"What size were they?" I ask.

"Eight."

Later that day I think about her again. I wonder if she would

take a pair of boots if I offered. She never seems to panhandle or ask for anything. I am worried about offending her, but I have a pair of boots that might fit her.

On a bright morning when I figure June will be out for a stroll, I decide to take the boots over to where she sleeps. Her boxes are joined together like a coffin with a small hood, weighed down with large rocks. This is her home. I walk closer, not knowing whether she is in there or not. Her shopping cart is parked behind the boxes. Finally I look in, feeling like an intruder.

Inside the boxes is a soft-looking, very clean mattress made of crumpled paper. It looks almost like one of the crèches you see at Christmas time. I'm relieved that June isn't there. I hide the boots at the top of her bed, where her head must rest. I hope she likes them.

Over one-half of the seniors who live in rental accommodation spend more than the accepted one-quarter to one-third of their income on rent. . . Developers in the private sector are failing to build housing for low or average income seniors.

—*1997 Seniors Election Handbook*

MOLE HILL: FIGHTING FOR COMMUNITY NEEDS OVER CORPORATE GREED

Not far from my apartment is Mole Hill, the oldest undisplaced community in Vancouver. Of the thirty-six buildings located in Mole Hill, thirty-three were built before 1909. It's the last full block of heritage houses in Vancouver. The houses are owned by the City and rented out; some people have lived there for forty or fifty years. Mole Hill is not "social housing"—no outside organization offsets rent prices. It is considered "low-end market rental housing," suites which have shared washroom facilities and therefore have lower rent than self-contained suites.

When the City announced plans to tear down some of the

buildings to put in more park space and new housing and condos, there was strong opposition in the community. If all the units were rented out they would generate enough revenue to pay maintenance and operating costs. Why should we demolish the existing houses and build new ones so that people with more money can live there? Is it more important for the government to get higher taxes from this site or to ensure that our housing is affordable and that we keep our heritage site? There is a social value to Mole Hill that far outweighs its economic value. A large number of elderly people have lived within Mole Hill for a long time. If they are moved, we risk their personal well-being.

Mole Hill is so different from the rows and rows of high-rise apartments where nobody knows anybody. These old-style houses with porches and back yards with trees are an oasis in the cement jungle that is the West End. On a warm summer afternoon in 1995 I went to a community barbecue to support the Mole Hill issue. Young and old hung out together in the sprawling back yards of two old houses. Neighbours brought home-cooked chicken and chocolate-crunch cookies and huge bowls of salad—so much real food.

A grey-haired woman with a bright smile walked slowly up to the microphone with a cane. She said she had lived in the area for sixty-five years and had come there as a young bride. She loved her community and didn't want to see it turned into condos. Another woman spoke passionately about keeping all the houses in the community, renovating the ones the city had already vacated and renting them out.

There are so few houses left in the West End and yet City Hall just wants more concrete jungle. As usual, the developers and planners spoke about community consultation, but folks aren't buying that anymore. We've already been burned too many times by their idea of community input, which means nothing when they go ahead and do what they intended all along. These planners all have the same body language: they weave in and out like snakes, waving their hands in circles, scratching their

heads, smiling with capped white teeth. When you challenge them they go red in the face, look angry and say, "Well, I'll have to take this back to the City."

The community organizing which took place around Mole Hill can be a model for other communities that want to work toward more healthy, liveable places. People were encouraged to contribute in the following ways:
• Attend and speak at City Council meetings.
• Write letters to the Mayor and all Councillors.
• Call people in the community to inform them about public meetings.
• Post flyers and posters.
• Sign petitions and get others to sign them.
• Contribute your energy and participate in defining and realizing a community-based planning process.

Over thirty organizations and 5,500 names on a petition supported keeping Mole Hill as is, old houses and a working-class community. Because of the dedicated efforts of many individuals and organizations, including the Mole Hill Living Heritage Society and Friends of Mole Hill, in September 1996, the City of Vancouver established a fifteen-member community-based Mole Hill Working Group to study the various options for the future of Mole Hill.

In February 1997, the Mole Hill Working Group presented its vision and a plan for preserving Mole Hill to the community and the City of Vancouver. It called for:
• the retention of all 168 units of the market rental housing for lower-income earners;
• minimizing the relocation of tenants during renovations;
• preserving all of the houses and the roadways;
• and enhancing the open spaces on the site for public uses (gardens, green spaces, sitting areas, etc.).

The Working Group also endorsed, in principle, an expanded childcare facility and a site for the Dr. Peter Centre, a hospice and daycentre for people with AIDS.

Just as I was completing this book, the City of Vancouver released a Policy Report (draft, dated 24 June 1997) to the Standing Committee on Planning and Environment. In contradiction to the recommendations of the Working Group, the City's recommendations would mean that:

• Tenants will be relocated from their homes within Mole Hill.
• Some Mole Hill heritage houses will be demolished.
• Approximately 50 percent of the houses will be available for 99-year leases. As a result, the houses likely will be converted from rental housing to "luxury" housing, affordable only to higher income earners.[2]

This latest development comes as a shock. Community activists put thousands of hours into organizing and trying to work with the City to preserve Mole Hill. Now it appears that the local government cannot resist making more money from this publicly owned land. We seemed so close to a victory of community needs over greed. The Mole Hill Living Heritage Society and many, many people in the community will keep fighting for people's right to affordable housing.

NOTES

1 "Hotel found unfit for human occupancy," by Kim Pemberton, *Vancouver Sun*, 13 June 1997.
2 Mole Hill Living Heritage Society, Public Notice, July 1997.

The Carnegie Community Centre and its Neighbourhood

I was scheduled to read at the Carnegie Community Centre on Literacy Day, along with several other people. Just when they announced I would be the first reader, the kitchen workers brought out the chili and bread and coffee. There was a lot of noise and the chili was the priority of the moment, so instead of reading I recited my Balmoral cockroach poem, followed by a loud rapping of "Thunder Thighs," which got their attention. Then I talked briefly about the serious danger of losing the Carnegie Community Centre if people didn't get organized and fight the government cutbacks and the real estate developers in the area.

I know one thing about grassroots organizing among poor people: feed us first, then talk politics. Politics on an empty stomach goes unheard because people are busy wondering where they are going to get some food for themselves and their children. A pot of soup or a bowl of chili is definitely an organizing tool.

The Balmoral Cockroach

In a Balmoral room a cockroach creeps
In and out of cracks
Looking for a place to lay
Her many tiny eggs.
She crawls into the pocket

The Balmoral Hotel is frequently used in the sex and drug trade in the Downtown Eastside. Shaughnessy is an affluent neighbourhood elsewhere in Vancouver.

Of a john getting tricked
Goes home with him to Shaughnessy
To live with his wife and kids

What is today the Carnegie Centre, on the southwest corner of Main and Hastings Streets in Vancouver, was built in 1902 as the first city library. The money for a library was donated by Andrew Carnegie, a businessman whose spiritual values placed human life above property, while his business values placed property above the needs of citizens. In an attempt to reconcile this conflict, he gave away close to 90 percent of his fortune, including $50,000 toward the Carnegie Library. On the third floor of the building was the Vancouver Museum, which took over the entire building after the main branch of the Vancouver Public Library relocated in 1957. In 1967 the museum also relocated, and from 1968 to 1980 the Carnegie building was empty and boarded up.

The Carnegie Centre was born because strong activists fought for it. In 1974, the City of Vancouver put the building up for sale or lease. The Downtown Eastside Residents' Association (DERA) fought for the next six years to get the city to agree that the building should be turned into a community centre for people who lived in the area. There were many bars on Hastings Street between Main and Cambie. The idea was that the Carnegie Centre would be a drug- and alcohol-free place, with a library, a theatre, a gym, a cafeteria, a learning centre and free programs for the people who came there. It would be a kind of living room for the Downtown Eastside. The Carnegie Centre opened its doors in 1980. Hundreds of volunteers and a small staff make this heritage building a happy, homey place.

I've been part of the Carnegie community for more than ten years. The people here have supported my books, and I learned how to read publicly and without fear by practising my poems

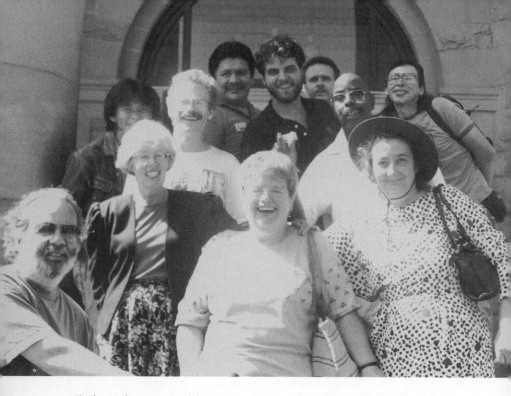

Sheila, in the centre, celebrating her VanCity book prize with friends and well-wishers at the Carnegie Community Centre in 1992. Copyright © Alan Twigg.

in the Carnegie theatre. I have learned about many different cultures through the people I meet as a volunteer tutor at Carnegie. Whenever I am lonely, whenever I am sad, as soon as I walk in the Carnegie doors I know I will always find someone to have a coffee with and share a problem or two. And there is always political organizing taking place at Carnegie, with delegations going to City Hall and petitions to sign.

I first started volunteering at Carnegie when I was working as a welfare advocate at the nearby Downtown Eastside Women's Centre. In 1986, I and a number of other community activists learned that the Carnegie Community Centre Association (CCCA) Board was badly divided and run undemocratically. We fought hard for a community approach to Carnegie's problems. In 1987 a loosely organized group called the Friends of Carnegie Users Society (FOCUS) began to meet to address the crisis in the

Carnegie Association leadership. A special general meeting of the CCCA was called and a new Board was elected in April 1987.

Since then, I've been involved in many of the struggles to preserve the Downtown Eastside as a community. There are many committed and creative people here who have waged—and won—some major battles. There was the 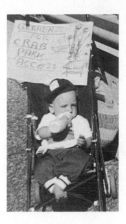 fight for a community beach which people in the neighbourhood called CRAB Park. People camped there until that victory was won. Then there was the huge fight against a proposed waterfront casino. The billion-dollar plan included a convention centre, mega theatre, cruise ship terminal, helijet pad and much more. A project that size would have swallowed up the Downtown Eastside like a giant tidal wave. People from all walks of life united to oppose this gambling extravaganza. Many groups outside the immediate neighbourhood formed coalitions to stop this expansion of gambling. Much evidence was presented from other cities with

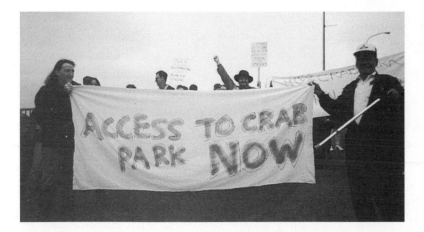

Demonstrating for access to CRAB Park, Sheila brought along her grandson Bobby (*top*).

67

casinos, demonstrating how gambling addictions created crime and drug epidemics in local communities. And we won! Rallies where we sold "No Casino" buttons, protests at City Hall, countless organizing meetings and strategy sessions paid off. The people of Vancouver rejected the casino proposal and the necessary permits were not granted. A sweet victory for the Downtown Eastside!

Another major achievement for the Downtown Eastside was the opening of the Four Corners Community Savings bank. Its co-ordinator, Jim Green, who worked for years for DERA, spent from 1994 (when the bank was approved by the government) till April 1996 getting this project off the ground. Its aim is to provide banking services to thousands of area residents on fixed incomes who normally can't have access to bank accounts. A person without ID can go to the bank, get a photo taken, get it signed by a social worker and use it to open an account and cash cheques at Four Corners. Regular banks won't cash income assistance cheques for people with no ID, so often low-income people end up cashing their cheques at Money Mart, which charges $10 to $15 for the service. They get all their money in cash, leaving them open to robbery and mugging. At Four Corners poor people can open accounts, deposit part of their cheques and withdraw some money each week. This bank has a washroom, a play area for children and a positive attitude toward low-income people. It also has an active community advisory council.

The Four Corners bank blends many cultural traditions. Its slogan is written in English, French, Chinese, Spanish and Vietnamese: "Banking with community spirit," translated in Spanish as "El banco con espiritu de comunidad." The name Four Corners refers to the importance of the number four in aboriginal cultures (four directions, four seasons, four stages of life). But because the number four is considered negative in Chinese cultures, green and gold were adopted as the bank's colours to counterbalance the four.

Modelled after community development banks in Chicago

and New York, Four Corners may finance low-cost housing and give loans to low-income people starting their own businesses.

An estimated 600,000 Canadians have no bank account, primarily because they lack the required ID. —*NAPOnews*, January 1997

Also in the Carnegie neighbourhood, the first steps have been taken to transform a parking lot into a home for forty-seven single women who are living at risk in the Downtown Eastside. This is a project defined and designed by the women of that community, and will provide much-needed housing and support services. The ground floor of the building will be the new home of the Downtown Eastside Women's Centre, which provides support for thousands of women in the neighbourhood.

By Spring 1997, the Bridge Housing Society for Women had successfully raised $6.1 million from foundations, government, service organizations and private donors. An architectural model of the building is complete, with construction slated to begin later in 1997.

Elsewhere in this book I write about other community organizing spearheaded by the staff and volunteers at the Carnegie Centre. Our work at Carnegie isn't just organizing for change. It's that each person is important, we care about each other, we nurture each other. You may never know whose life you have changed. My friend Bob, who is the best community organizer I have ever known, has been working for years to make Carnegie the model community centre. Recently when we were talking about our fears that the future of Carnegie could be threatened, he said he had been feeling pretty down after so many years of struggle. I reminded him of all the people whose lives he had touched and improved. He gave me a lot of support around my writing, and in turn people who have read my books have told me that their purpose in life changed.

True Stories of Aging and Dying

My aging is something I resist—refuse, even—to face, pretending "It ain't gonna happen to me." Already, though, cashiers are impatient with me, salespeople ignore me and finding a doctor who will listen is difficult. I dye my hair just like my Grandma Daisy did.

Watching TV reinforces why we dread aging. Commercials tell us wrinkles are ugly, grey hair is ugly, facial hair is ugly. According to the ads I will need diaper-like underwear to make sure I don't drip and laxatives to stay regular and drugs to stay good-natured. So many products I must buy to be acceptable to society. Most of my life I've been fat and unacceptable. Now I'm aging and wrinkled and fat—thoroughly unacceptable. I have to hold on to knowing who I am, and that I am not disposable. I am Sheila: lover, mother, grandmother, activist, writer. My mind is strong. I am not my wrinkles, my age or my fat. Those are just a few of my body parts. My soul, my spirit, my breath, my life are so much more.

When I die I want to be cremated and to have my ashes put under a large tree near a lake. I want to be recycled into the earth. Maybe that way the tree's roots will be fertilized by my ashes and my spirit will live on.

When I look around me sometimes I see an epidemic of loneliness among elderly people. It's like a rapidly spreading disease, a complex societal problem that our culture is not dealing with. Many elderly people live in a room with a TV, a couch or a bed, and perhaps they receive Meals on Wheels. The only time they are touched is when a homemaker or a nurse comes. Some of these people welcome an emergency visit to the hospital just to

have someone care about them. I see a waiting-to-die syndrome and it makes me truly sad.

One day recently when I went outside my apartment building there was a body lying there with a sheet partly over it. A foot with a running shoe stuck out and I could see it was a large man. Blood trickled slowly on the cement but the police and ambulance attendants weren't doing anything so I knew the person must be dead. Tenants were buzzing like bees, everyone wanting to know, Who was it? What happened? Was it a murder, a mugging?

I found out from the caretaker that it was my neighbour, a man who always smiled at me and said hello in the elevator. He was a tall, polite, cleanly dressed man who came originally from the Prairies. We often sat together on the Robson Street bus and we would chat. He told me what he bought in Chinatown to get rid of bugs in his apartment. Apparently now he had committed suicide by jumping from the fifth floor of our apartment building where we have communal gardening boxes.

On that day my roses were budding and some small green tomatoes showed great promise. The sage was a dull green and the parsley a brilliant green, each with its distinctive scent and flavour. And here my neighbour had come up to the garden and ended his life. I went up and looked at the spot he jumped from, not far from my sage and parsley. Looking down I could see the blood stain on the cement that would soon be washed away. And I wondered if he took his life because he was old and lonely.

Just recently another elderly man slashed his wrist and then wanted to jump too, but someone stopped him "Look," he said, "I cut my wrist and I don't even have enough blood to bleed to death." He was taken to hospital and recovered. I remember how he used to love to smell my flowers. Was he, too, struck by the epidemic of loneliness?

I live in a large complex that houses a lot of elderly people. Several of my neighbours have terminal illnesses and I'm aware of this when I say Hi to them. Today I went to the caretaker's

> **Reform . . .**
>
> It used to mean "making things better." Now, when applied to social programs (for example, "reform" the UI system), it nearly always means "to make things worse" for low-income people.

office to get a key. On the wall was a huge white notice board, the kind you write on with a felt marker that can be wiped off, and I was shocked to see the number of suites that had vacancies and beside them the word "dead." The caretaker told me that the most deaths are around Christmas. It makes me think that a lot of old people die of loneliness. At Christmas there's so much media hype about buying for someone you love, phoning someone you love. A lot of my neighbours never seem to have visitors. I bet their phones don't ring and there's nothing in the mail except an ad for a burial plot.

It reminds me of my old neighbourhood on Selby Street in Montreal, in the 1960s. People who had lived in old homes for over sixty years were forced to move to the suburbs when their homes were expropriated. They died of loneliness. Older people need their friends and their community. It really is a contributing factor to the health of senior people. I'm getting a little older myself and I don't want to be thrown away into a strange environment either.

SAYING GOODBYE AT CARNEGIE

Recently I attended a memorial gathering at Carnegie Centre for Stan, who died at age eighty-nine of Alzheimer's disease. He had been a volunteer at Carnegie for a long time, and I knew him as a kind and funny man. He lived with my friends Bob and Muggs. He often got lost because of his Alzheimer's, but people in the Downtown Eastside would keep an eye out for him. I found him once after he had been missing for hours.

Bob and Muggs courageously and with great kindness nursed Stan and made it possible for him to die at home. In the final

stage before his death he had to be diapered like a baby. They held his hand and comforted him throughout the night before he died, and he passed on peacefully. Muggs and Bob even took on the difficult task of cleaning him up after he died, because they wanted to "prepare" him the natural way.

When Bob called me about Stan's death he invited me to come over to their house to say goodbye. There would be no undertaker, no embalming, no painted corpse in a funeral parlour. I rang their doorbell, found the door open and went up the first flight of stairs to Stan's room. There was Stan in bed wearing his sweat pants, with his grey hair brushed back. He looked good, just as if he was asleep. I said "Hi Stan," although I knew he wouldn't answer. Bob came into the room with me and I sat on the chair beside Stan's bed stroking his soft, silvery hair. A Mitch Miller song, one of Stan's favourite tunes, was playing on the tape deck and I sang along. Before leaving I gave him a kiss and said goodbye. Neighbours and friends with two small children dropped by. The children played in the doorway where Stan lay peacefully in his bed. We all went downstairs, ate food and looked at pictures that spanned over eighty years of Stan's life. I left with a happy feeling, knowing that's how I would like to die, safe in the arms of loved ones in my own home.

Stan's death reminded me of my first experience with death, when I was eighteen and living in Brixton, England. My grandpa, Walter, was dying of cancer at age sixty-three, and I visited him in the hospital. His large labourer's hands had always been callused—he used to say washing the supper dishes softened his hands—but now they were pale and unfamiliar. I held his hand, I knew he was in pain, and the last thing he said to me was, "Who's gonna take care of my Daisy, who's gonna take care of her?"

When he died he was laid out in the parlour on Grandma's dining room table. Grandpa had on a shirt and tie, which I'd never seen him wear before. My father was there—it was the first time I'd seen him in years. He held my hand as we approached

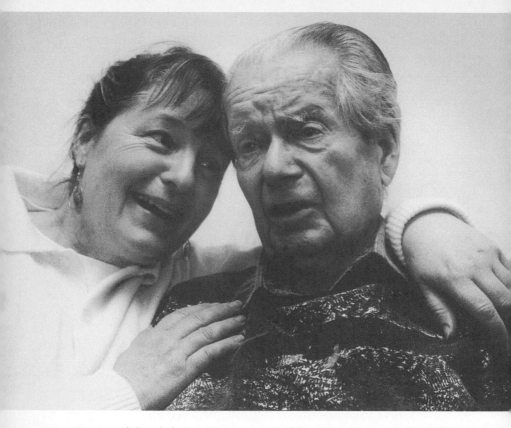

Muggs with her dad, Stan. Stan was part of the Carnegie community until his death. —Copyright © 1994, the *Vancouver Sun*. Reprinted with permission.

the table where Grandpa lay, and he told me not to be afraid. My father stroked Grandpa's hair, just as years later I was stroking Stan's hair, then kissed him. I bent over Grandpa, noticing his thick, grey hair. His face was still the face of the very sweet man who had called me Tootsie and shown me so much love. I kissed his head, terrified by the coldness of his skin. I wanted his blue eyes to open and for him to say, "How's my Tootsie?"

Like my grandfather, Stan was also a very sweet man. The week of Stan's death, a memorial was held at Carnegie. It was a happy event, with people telling lots of "Stan stories" and eating

beef stew, fresh veggies and cake. It was a time for meeting peo-
ple you hadn't seen for a while and catching up on all the news.

One of the reasons why I've come to appreciate memorials at
Carnegie is because this is a community that knows how to
mourn its dead. It's a tradition at Carnegie to hold a memorial
when someone dies. Food and coffee are served and there are
flowers on the front table surrounding a photo of the person who
has died. We play the person's favourite music and whoever
wants to can go up to the mike and say something about the per-
son we are remembering. There are tears and laughter as we
grieve, lots of hugs and a real sense of unity. Many people in the
area may only have a welfare funeral, but when it comes to the
memorial services at Carnegie, the poorest of us are the richest.

In 1995 there were 339,000 poor single women and 56,000 poor
single men over age 65. — *Poverty Profile 1995*

Another Carnegie friend I remember is Bill Running Horse. He
was on kidney dialysis three times a week at St. Paul's Hospital,
and he wanted a tutor to help him write his stories to pass the
time. I went a few times, and one day Bill asked me to have lunch
with him. We had a good time. Then one Monday when I arrived
at the hospital, I couldn't find him. A nurse told me he had died
that weekend. His kidneys had stopped functioning. The ambu-
lance had come but he had refused to go to the hospital, choosing
to die instead. I remembered that on our last visit he had talked
about Native people he knew who had committed suicide. I also
remembered a story that Bill had told me. Once on an all-night
drive out west somewhere in his truck, he started to feel really
tired. His truck door opened and closed and he felt someone
get in and sit beside him. Yet there was no one there that he could
see. He felt the invisible presence all through the long drive.
Come dawn, when he reached a town and stopped for coffee, the
invisible person vanished. "I am not making this up," Bill said,
"there really was someone there on that long drive."

On the day when I learned that Bill had died I felt my knees buckle and pain shot up through my gut. I sat for a while at the hospital and finally staggered over to Carnegie to find some friends to mourn with and to hold me in my grief.

I also remember the memorial for Jody, a woman in her thirties who committed suicide. Jody had a small apartment in the Downtown Eastside. She paid her rent on time and volunteered in the community. But then she had to go into hospital, and when she came out she found her apartment gone. She had to live in a room over a bar in a hotel on Hastings Street, with flimsy locks on the door and the bathroom down a long dark hall. It was all she could afford on her welfare rent allowance. It was her worst fear to have to live like this, and so she chose to take her life instead. Her social worker said at the memorial that poverty had killed Jody. If she had had enough money to start over with a decent place to live, she probably wouldn't have chosen to die.

"Poverty, for many, is a life sentence, with no hope of parole."
—*Dispatches from the Poverty Line*

DYING WITHOUT A COMMUNITY

In the building where I live in the West End, a large social housing complex for seniors and people with disabilities, people often die alone. In the three years that I've lived here there have been four deaths on my floor. Sometimes when people die here they are not found until the smell of death seeps out of their apartments. It is a smell that lingers long after the body has been removed, a terrifying smell hard to erase from the mind. In my building when neighbours die often they are taken away and there is no memorial service because they are not part of a larger community. There's no one to mourn them and no way to say goodbye.

A few years before I lived in the building where I do now, I knew a man named Willis who lived here. I knew him from Carnegie,

and I knew he was writing a book about his experiences. During the 1930s he had been on relief and was involved in organizing the Relief Camp Workers' Union. He was among the unemployed workers who occupied the top floor of the Carnegie building in 1935, when it was a museum, and he went on the On-to-Ottawa trek. He would always say, "Let me teach you how to play chess, Sheila." "Later, Willis," I would reply. "I don't have the time now."

One day when I came to Carnegie I was told that Willis had died, and that several days had passed before he was found. His family came from back East to bury him, and I went to his grave-side. I asked a male member of Willis's family where the book was that Willis had been writing. "Oh, we had it shredded in case it got into the wrong hands," he replied. I cried and cried as Willis's coffin was lowered. The record of his life's work had been destroyed, and I never did learn to play chess. Sometimes now I feel his loving spirit urging me to keep resisting.

I've had many close-up experiences with death since living here. My neighbour Bob was a forty-six-year-old taxi driver, a hard-working man with heart disease. He was a heavy smoker too and he couldn't quit, even when he was waiting for a heart transplant. Puffing away on a cigarette, he told me one day that he had been taken off the transplant list because he wouldn't quit smoking. I took a couple of pictures of him because he told me he hadn't had a photo taken in years. When I went to bring them to him, I found him in bed, looking swollen and grey. Yet he still smiled at me and was so happy to get the photos.

A couple of days later a neighbour said, "Did you hear that Bob died?" "No, when? How?" I asked, thoroughly shaken. She said, "Out there on Denman, he died on the sidewalk." There was no memorial for Bob so I didn't get to say goodbye. His apartment was already being cleaned out and there were just bare marks on the walls where his posters had been. The care-taker offered me Bob's pet fish, which I've had now for a couple of years. It's a strange fish, it won't allow any other fish in the aquarium. So it lives alone, just like Bob did.

Another man in my building, an elderly man who looked like he had had a stroke, would often fall down outside and be unable to get up. Neighbours called an ambulance but the next day he was back on the sidewalk. Late one night neighbours found him lying on the sidewalk in the rain with one leg stuck out stiffly at his side and his arm paralyzed. They helped him home and woke up the caretaker to let the man into his apartment. He stayed in bed for days, not eating and incontinent. The smell coming from his apartment was so bad that neighbours called the health department. It took days to get him a bed somewhere. When he was taken away, his apartment was closed up without being cleaned. It stayed that way for two weeks or more, reeking of urine and faeces, despite many calls to the health department.

Two women who are older than me often sit talking on the bench outside our building. They seem to know everyone's comings and goings, and everything that's going on. I say Hi to them when I'm on my way out, and we talk about the flowers and how nice the weather is.

Yesterday I asked them, "What happened to that young guy in the wheelchair who couldn't talk very well?" He was severely disabled and sometimes would panhandle outside the Robson Market.

"Oh, he died months ago," Agatha said. "Didn't you know? They say he hung himself on the fridge."

I was shocked. "How is that possible?" I said.

They nod their heads and say, "Well he's gone, and that's what they say happened."

As the cuts to health care continue, I'm afraid more and more poor people will suffer like this from lack of services. And as more and more older working-class people lose their homes and communities to developers, the chance to die among friends is also lost. What we've seen is just the tip of the iceberg.

I have to remind myself that I know many older folk who are happy and busy. We need to develop networking with friends as part of a healthy lifestyle before we get old. And to remember that we are more than our age.

Someone to Wrinkle With

for Hadi

My love has beautiful eyes, so dark
Mine are blue.
My love has skin a golden shade of honey
Mine is pale, freckled.
Colour and culture we do not share,
Our love like a rollercoaster
Of highs and lows
Finding in each other a common need
For love, hugs, walks, talks
Sharing past pain
Future dreams.
Someone to wrinkle with
Someone to be alone with.
We birth alone
We die alone
So hold my hand, let's share, my love
Let's walk, my love
Until we say goodbye, my love.

Approaching Fat from an Activist's Perspective

I have been waiting for months for knee surgery and recently was sent to a medical lab for some tests. I was lying on the bed with wires and machines all around me and the technician started to verbally abuse me about my weight before he even began the tests. He asked me how much I exercise and didn't listen when I started to explain that I had exercised regularly until my knee injury and that now I couldn't while I was waiting for surgery. He said angrily that I was expecting doctors to do everything for me, as if they were magicians, when I should be doing something about my weight.

Lying there with pillows under my backside and pads wrapped around my thighs, I felt so powerless and filled with shame. The technician asked, "How far can you walk?" I responded that if I've cleaned my house or exercised I can't walk far but if I haven't done much I can walk a little farther. He responded angrily, "Just answer the question! How many blocks do you walk?" I tried repeating my explanation but he yelled, "How many blocks?" I gave in and said, "Four blocks," and that's all he wrote down, with no explanation. The verbal abuse continued with each new question. He wouldn't allow me to explain myself because he hated my fat. Yet he was fat too.

Rage bubbles up in me when I think back on that incident. How I wish I had told him, "My weight is not your business. Just do your job." To have my medical problems not taken seriously because I'm fat is not acceptable.

The chances of a woman having the "ideal" body are 1 in 40,000. The average woman would have to lose 1/5 of herself to be shaped like a model. —*Fat!So?*, #4

When I saw a back specialist recently, he told me that if I didn't lose weight I would face surgery and there would be a 50 percent chance that it wouldn't be successful. I told him, "Diets don't work for me." He said, "If I dropped you off in Africa, you would lose weight." The only exercise he instructed me to do was walking fifteen minutes twice a day, even if it hurts. I asked when I should make another appointment and he said, "When you've lost thirty-five pounds."

I went to my local doctor and he said there is no magic cure for weight loss. After forty years of doctors and dieticians dispensing advice, now they tell me, "You're on your own." At least this doctor was honest. I like that.

There is more and more evidence that yo-yo dieting makes you ill, and doctors are finally admitting that 95-98 percent of people who diet gain their weight back. Here they have been tormenting us for years with diets and now they turn around and say, "Whoops, sorry, we were wrong. Dieting doesn't work."

So I've decided to use my organizing skills, my activist background and my survival instinct to approach weight loss. I know I can do a better job than diet plans that destroy your self-esteem and your body's metabolism. To begin with, I need to remember what doesn't work, what has never worked for me over the past forty years. By applying my activist instinct to the weight-loss issue, I may just save my life. And I hope that other people who have also been patronized, shamed and made ill over weight loss may also benefit.

My first horrific experience happened in England, during my pregnancy with my first child. At the time, military hospitals had been forced to accept civilians on maternity wards, and my doctor was a huge military officer with a big moustache and a loud voice. During my pregnancy he often called me fat and yelled at me to get some willpower. I was scared of him and the more frightened I was, the more I ate. When I had been in labour many, many hours, my doctor wouldn't attend to me

In 1995 in the U.S., there were 30,000,000 women and 18,000,000 men on diets on any given day. —*Fat!So?*, #4

Annual sales of weight-loss products and services are currently estimated at $3 billion in Canada and more than $40 billion in the United States. —*No Fat Chicks*

because an officer's wife was also in labour and she got priority. The doctor yelled at me, "Be quiet. You're a coward, you're disturbing the other patients."

I was twenty-one years old, my baby was big and after the delivery I needed stitches. The doctor waited until the next morning to do the stitching and he did it without anaesthetic. I screamed in pain and still he kept calling me a coward. It was as if he enjoyed every stitch, as if he was punishing me for the weight I had gained. I'm sure this doctor's abuse was a contributing factor to my weight gain. A deep-rooted shame took hold in me. I know now that what he did was wrong, but for many years that experience and other factors contributed to my shame about fat.

After my son was born, my hips became wider and my husband kept telling me I was fat. I went to my doctor and he prescribed Dexedrine, which was commonly prescribed for women as an anti-fat drug at that time. I lost forty-five pounds, but I hardly slept, I never stopped talking and I cleaned my house till it was spotless. When I stopped taking the drug, the weight came back; in fact, I gained seventy-five pounds. My metabolism has never been the same since.

In the early 1970s, after we had moved to Canada, I saw a notice that the local psychiatric hospital was looking for volunteers for a weight-loss program. I had four kids and an abusive husband who would say to the children, "Walk behind your mother so nobody can see her fat legs." I thought if I lost weight the abuse would stop. My memories of the experiment are kind of hazy, but I remember sitting in a darkened room. There were

coloured lights that I could control by pushing the buttons on the arm of my chair. A young male student held a piece of short-cake under my nose. I was told it was covered with faeces, and it sure smelled that way. Before long the experiment stopped; the students running it had found other jobs, they told us. I stayed fat, but faeces smelled like strawberry shortcake to me for quite a while. Changing diapers or cleaning up after the dog never bothered me.

My husband claimed to hate my being fat yet he sabotaged every attempt I made to lose weight. That's when he would bring me chocolate. When I was expecting my first daughter I had a great doctor who encouraged me to eat lots of fruit and vegetables. I managed to lose weight and was down to about a size sixteen. One day I was out with my husband and children when a man who was passing by commented on how cute I was. My husband threatened to kill the guy; then we went right home and he ripped my clothes off, called me names and hurt me. That was the last time I fit into a size sixteen.

As I gained more weight, my husband kept being abusive about my fat. When we would get ready to go out together, he would make me keep changing my clothes until I had tried on everything I owned, which wasn't much. Then he would say, "You're too ugly." He would tell me about all the women he wanted to have sex with: neighbours, friends, members of the Legion we went to, all the while telling me how much he hated my being fat.

When my fourth child was born, I had a breakdown. I couldn't stop crying or eating. I was very depressed for a time and I felt extremely guilty about needing psychiatric help. The psychiatrist told my husband he was the one who needed help, that I needed to have some enjoyment in my life, but my husband refused treat-ment. For a while I attended an outpatient clinic but I was forced to leave because I had nobody to take care of my children.

Over the years I saw countless doctors who sent me to appointments with skinny dieticians who told me to count

calories, limit my daily intake to 900 or 1,000 calories. Eat half a slice of toast, a quarter of a muffin, half an apple. You have to have willpower, was always their chant. Bake cakes and pies for your kids and your man but don't eat any, or you're a pig. Luckily I could never afford the Scarsdale diet, and I refused to have my stomach stapled. I did go on a high protein diet that included eating bacon, butter, cheese, all kinds of fats. I got terrible heartburn from those foods and I wonder if that diet caused my gallstones.

Twenty-eight years ago I joined TOPS (Take Off Pounds Sensibly). We had to wear hats and buttons with illustrations of pigs. We had to say publicly, "I am a pig." Oh the humiliation. I gained thirty-five pounds. When I looked into that program again about eight years ago, it was less harsh, but still not for me. They had us singing songs about wanting to be slim so men would whistle at us.

I also joined Overeaters Anonymous (OA), and for a while I lost weight. I went there expecting to meet other women with big legs and big bodies, but so many of the women were slim and trim. I couldn't figure it out: here were these totally gorgeous-looking women—they looked like models—and they were all scared of being too fat. At OA I got a lot of praise and glory for losing weight, but it was a fragile high. At a certain point in the program I had to write down my character defects and confess them to someone. For me that was not constructive. I know society considers me defective because I'm fat, and this exercise brought on feelings of being no good. I became depressed and food became my only comfort. Then I would creep into OA meetings feeling terribly guilty because I was gaining weight. I've learned from this that mental beatings, whether given by someone else or myself, don't work. That can't be part of my search for a solution.

For years I suffered with dry eyes, headaches, shaking, painful muscle spasms, alternating tiredness and super speediness. Then

"You're not fat, you know, Grandma," my six-year-old grandson Ben said. "You're just like a soft fluffy pillow. I love hugging up with you. My mom has kind of a pillow too. It's hard for some kids whose parents are full of muscles, because they have no pillow."

in my early sixties I started waking up at night with a hot red face, sweating, choking, unable to breathe. I thought I was going to die. My trusted doctor, whom I had been seeing for twelve years, said, "It's panic attacks." He offered me tranquillizers of some kind. I said, "No."

My family was angry with me. I was so speedy, so nervous, so irritable. The most basic things became impossible to do. I couldn't read the labels on cans at the supermarket or write a letter, because my brain was racing. I couldn't even take change out of my purse because I trembled so much.

I went to a sleep disorder clinic, where they told me I needed to lose weight. I knew my symptoms had stayed the same over the years no matter what my weight was. Nonetheless, I came to believe that my physical problems must be because I was fat. I also knew that my body couldn't handle the speed or the night-time choking and flushes much longer.

I decided that if I was about to die, I wanted it to be in my living room under the large windows where I could see the sky. I moved my bed out there and made the bedroom into a work space. When I woke up at night, choking, the stars and the moon somehow calmed me. But I didn't die after all. Even though I had pretty much given up, my guiding spirit made me go to a local medical clinic. I told the young doctor there my symptoms and he sent me for a blood test. The test showed that I had an extremely overactive thyroid gland. That's what was making me speedy. I had something called Grave's disease. It hadn't been diagnosed because Grave's is usually a thin person's disease. Now I have to take medication for the rest of my life, but most of my symptoms are gone and I am functioning very

well. Unfortunately, since my thyroid problem has been treated, I've gained more weight.

"Wimmin flaunt your fat" was spray-painted in huge letters on a wall in East Vancouver. But in our culture it is more acceptable to be dying of starvation than to be fat.

The steps I'm going to work on now are the following:

1 To fight fat phobia and to resist all media messages that trash me.
2 To be assertive with the medical profession.
3 To never accept criticism from anyone about my shape. My fat is not their concern.
4 To wear whatever is comfortable, regardless of whether it looks slimming or not.
5 To not deny myself food. I will try to keep a healthy balance in my eating but if I slip up, that's okay. Skinny people slip up all the time and if it's okay for them it must be okay for me too.
6 To do gentle exercise, stopping and resting when it hurts. I'm going swimming and seeing a physiotherapist.
7 To stop being critical of other fat people. In the past I've been critical of fat people because I'm critical of myself. This must stop.
8 To not get all puffed up about how great I look when I lose some weight, because that sets me up for a fall.
9 To not depend on people's praise. Instead, I must accept myself unconditionally and depend only on my internal voice.
10 To be honest with myself. I am fat. My grandmother was fat and her mother was fat. There is probably a genetic factor in my fat.
11 To do more activist work to expose the diet industry.
12 To walk with my head held high and a smile on my lips because I enjoy being a female human being on this planet earth. We come in assorted colours, shapes and frames—one is not any better than another. When we die we are all just dust.

Oh So Thin

The young girl, barely twelve
Worries about her developing shape
Weighing just over eighty pounds
Feels fat, oh so fat.
Models strut the walk, hollow eyes
Fatless frames, bone on bone
Mannequins pose in store windows
Bent in impossible positions
Their lifeless faces gaze out onto the street
Like Barbie Doll, long, slim, almost no hips
Thin, oh so thin.

The young girlchild accepts the images
These artificial women portray.
Trying to achieve the impossible
She diets, becoming bulimic
Or anorexic, food obsesses her
She purges and purges
Downing endless laxatives
Teeth rotting in her head
She nearly dies.

Now she is thirty-something
And understands that Barbie dolls are sick
Oh so sick.

I decided to take on the diet industry for making fat people feel like freaks. Once too often I had seen ads like the following on TV:

> A charming young black woman says she just graduated from college and was preparing for job interviews. "And to be honest with you, I was fat. I was a size sixteen."

That's when she decided to go to the Jenny Craig weight loss program. Now she feels great. She can wear a size eight dress. "Now I feel I can go out and get *any* job."

An attractive white woman is in a store looking for a bathing suit. She takes one to the dressing room to try it on. Suddenly we hear a terrifying scream, as if she were being raped or murdered. In fact the woman screamed because of her image in the mirror. It turns out to be another Jenny Craig ad.

I am horrified by the messages in these ads. Young women accept these images and try to achieve the impossible. They learn that you have to be skinny to get a job as well as to go to the beach. For decades our culture clung to Barbie as the ideal body-image for women. Today's models are even skinnier; they don't even have the large breasts anymore; they are just bone on bone, hollow-eyed mannequins.

Surveys have shown that children as young as six see overweight peers as stupid and less likeable. —*Big, Bold and Beautiful*

I was so stressed out by these ads that I called a friend who is also a large woman and decided to start a movement called Large People's Rights. I wrote a press release and made a simple poster. I asked friends to photocopy them for me and to fax them to local media. The *Carnegie Newsletter* and the *West Ender* newspaper published my news release. Taking action when you have no money is a challenge, but there is always something you can do. It's so empowering to take on an industry that trashes large people. If everyone who supports Large People's Rights complains every time they see an anti-fat ad, our protests can create a pyramid effect. We don't even need meetings, just speak up.

Recently a friend and I were having coffee at a new health

food restaurant. The green plastic chairs we sat on were so wobbly that I was scared to move. "Oh my god, I'm too heavy for the chairs," I thought, and the usual shame/blame crap entered my mind. Then I remembered: large people have rights too. I asked the young man who worked there how much weight the chairs were designed to hold. To my surprise he said that six chairs had already broken and that they were sending them all back. I'm so glad I spoke up instead of internalizing the fat phobia. I wasn't the problem; the defective chairs were. Speaking up is a victory for Large People's Rights.

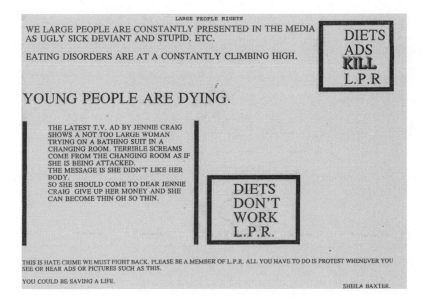

One day I put up some of our posters on the street. The next time I walked by I saw that someone had scrawled, "Fat slobs, fat slobs" across one. I immediately felt shame, pain, unshed tears. Then reality set in. This is proof of how much hatred of fat there is out there. People hate other people and themselves just because of their body size. For me, deciding to resist fat oppression has freed up a lot of energy. The diet industry is about making money from vulnerable people. Part of my political work is

fighting back. I invite you, the reader, to get involved. Write letters, phone TV stations, seek legal advice about class action suits. Explain to parents how damaging weight loss ads are for young people. Anorexia and bulimia are killing teenagers and the root cause is our society's fear of fat. Complain when life insurance companies deny coverage to people who are "overweight"—this still happens routinely. Large People's Rights is about claiming our dignity, taking our space and challenging other people's fatphobia. Fat people suffer pity, irritation, condescension and anger. These are not our problems but constantly dealing with them wears us down. We are viewed as evil, selfish, bad examples—some of the same stereotypes that are applied to poor people.

Several of my women friends who are large like me keep their arms covered even when the weather is really hot. They say things like, "My arms are too big; I can't show them," or "I would never let anyone see my large arms." One day last summer I decided to liberate my arms. What a sense of comfort it brought! I put on a sleeveless T-shirt and a sleeveless vest and strutted my stuff down Vancouver's Robson Street. It felt wonderful. I even contemplated for a brief moment getting a tattoo or maybe an upper-arm bracelet, a symbol of my determination to fight back.

"Riot. Don't Diet," a graffiti artist wrote over a diet billboard. It was only up for a few days before a new diet ad was plastered over it.

Lorna Boschman, a Vancouver video-artist, asked me to be in a video she was making about fat oppression. I said sure, as long as I could write and perform my own anti-diet commercial. So that's what I did. I was filmed as a newscaster, with a raging fire behind me: "Warning! Warning! This is a special news bulletin. Regular programming will resume after this announcement. Warning! Use extreme caution when media ads encourage you to diet. The diet industry portrays fat people as ugly, deviant and socially unacceptable. This is fraud. Beware. Be cautious."

Now Lorna is working on a film called *The Seven-Day Poodle Diet* and a book that looks at issues such as dieting, the fashion industry, and fat and sexuality.

According to the National Association of Anorexia Nervosa and Associated Disorders, the total number of American girls and women with eating disorders has topped 11 million. There are 150 times more women on this continent who suffer from eating disorders than there are female AIDS patients. —*No Fat Chicks*

Since starting to claim my space as a fat woman, I've come across a great little zine out of San Francisco called *Fat!So?*, "for people who don't apologize for their size." This paper encourages us to laugh at ourselves and our fatphobic friends and families, as well as to express our justified rage. It includes personal stories about anti-fat discrimination, solidly researched articles about body size and health issues, and fun drawings and writing by fatsos. It recently featured a "Fat!So? Manifesto" which suggests direct ways of changing our own thinking about fat and challenging fatphobia. Here are some examples:[1]

1 Refuse to be weighed during visits to your doctor. If a health professional pressures you to get on the scale, ask what possible medical purpose it would serve. The doctor's scale is a tool of intimidation and humiliation, a means to justify the medical industry's anti-fat bias.

2 Stop lying about your weight! Especially on drivers' licenses. This practice reinforces fatphobia and hinders size acceptance. Practise honesty right now. My name is _____. I weigh ____ pounds.

3 Practise saying the word fat until it feels the same as short, tall, thin, young or old. Combine the word fat with other words in new and unusual ways: beautifully fat, fat and fabulous, fat pride. Try out these radical phrases on people you meet and watch their stunned reactions.

One of the things I enjoy about this zine is its down-to-earth language. It recently conducted a reader survey which asked such things as "What do you like about being fat?" These writers don't mince words any more than they pare down their body size. It's really refreshing to see headlines like "Big Fat Truths" and "How out are you about fat?"

In her book *No Fat Chicks*, journalist Terry Poulton challenges what she calls the eleventh commandment for women: *Thou shalt not be fat*. She traces the evolution of our society's obsession with thinness and the conspiracy which teaches women of all sizes to hate our bodies. She concludes that "three big lies" underpin the entire process: [2]

1 that fatness is the worst cultural catastrophe that could happen to women;
2 that obesity *must* be voluntary because any woman could be slender if she tries hard enough and spends enough money; and
3 that the sole cause of all excess weight is therefore despicable self-indulgence.

In a survey reported in *Newsweek* in 1990, 11 percent of the respondents stated that, if genetic predisposition to obesity was identified in their unborn child, they would opt for abortion. —*No Fat Chicks*

In my life, people see the fat first. They don't see me first as a writer, an activist, a grandmother, but as a fat woman. No matter what else I do in life, the fat always comes before what I am.

A long time ago someone gave me a beautiful cloth-bound journal in which I wrote for many years. Recently when I got the journal out and started to read it, I got very sad and angry at myself. There's so little mention of the books I wrote, or of the births of my beloved grandchildren, or of summer sunsets. Just pain over being fat.

Fat is so repulsive to so many people. Their worst fear is becoming fat. One woman told me, "If I was fat like you I would lock myself in a closet until I lost the weight." We are so vulnerable, as women, when even those of us who are size five think we are fat. What keeps me sane is going to art galleries and looking at paintings of women with big breasts and big hips. I look at these women who have hips and legs with flesh and who are plump and I think they're beautiful, they look so sensuous.

Thunder Thighs

She has thunder thighs
And her breasts hang low
To her children she's one hell of a woman.
She has thunder thighs
And her belly sags
To her lover she's the perfect woman.
Thunder thighs, thunder thighs
Strong, powerful thunder thighs
Thunder thighs, thunder thighs
Strong, powerful thunder thighs.
She has thunder thighs
And a mind so strong
She is one hell of a woman.

A woman who is fat is 10 percent more likely to live in poverty than a non-fat woman. —*Fat!So?*, #2

NOTES

1 *Fat!So?* #2, Copyright © 1994, Marilyn Wann.
2 *No Fat Chicks: How Women Are Brainwashed to Hate Their Bodies and Spend Their Money*, by Terry Poulton (Toronto: Key Porter Books, 1996), p. 76.

Writing Is Fighting: A Voice for Poor People

My friend Bob Sarti, who is a newspaper reporter, once described me as a literary guerrilla. I thought it was a wonderful compliment.

My books are about my life and the communities I have lived and worked in. Poor people's voices are heard in my writing. I empower them and myself by writing about the truths that we don't ever see in the regular media. I see myself as a writer of community truths. My writing is what I have to offer, and it's the legacy I leave to my grandchildren. Two of my grandchildren, Melinda and Lea, are writers themselves. Once Lea was interviewed by a reporter who came to her school to talk about the grey whale issue. When the story appeared in the paper, Lea said the reporter hadn't quoted her properly. "Write a letter to the editor and tell them what you really wanted to say," I told her. All of my eight grandchildren show my books to their classmates and teachers, even though there is the occasional swear word in them. They are proud of their activist grandma.

As a writer I see myself as part of an endangered species. I am poor; I write about things that the right wing doesn't want to hear about and wants to suppress. As the costs of publishing keep going up I get scared that we will go back to a time when only the rich can write our history, dishonestly of course. My books are used in colleges and universities all across the country, yet because the cost of producing books has climbed so rapidly, sometimes my books are out of print for months at a time. Small and alternative publishers are becoming more and more financially stressed and are being strangled into non-existence.

PRISON WRITING

A few months ago I was invited to give a writing workshop in a
women's prison. I had to leave my purse in the front security
area, and then I was escorted into the prison. It reminded me of
a goldfish bowl, all glass walls, with guards watching me from
the other side. In the learning room, where the workshop was
being held, a group of women sat around a table.

There were straight and gay women of all ages, shapes and
sizes. Except for one woman, we were all poor. It took some time
to break the ice. I talked about my own poverty, my abuse as
a child, my homelessness. I opened myself up to them, and
in return they showed me their hearts. We began to share with
each other our writings and poems. I could so easily have been
in the same place. Several of the women had not seen their chil-
dren in a long time. Some had families who couldn't afford to
visit them, since the prison isn't on the bus route. There were
poems about missing their babies, and about longing for a lover's
arms.

One very young woman with a soft face and some slashing
scars on her arms said she hadn't ever written poetry. I told her
that poetry is just something you feel and write down in lines—
it's the hurts and joys in your life. She wrote a poem right there
and then and I said, "Now the tap has been turned on, you
won't stop." Her teacher in the prison, Mary, told me they had
been trying to get her to write a poem for a long time, and in a
very short time I helped her achieve that. So we wrote and we
talked and we laughed and we cried. I didn't ask what they were
doing time for. We were there as women writers. When I started
to write and when I had my first book published, that was my
way of fighting back, defending myself. If my friends in that
Burnaby prison are reading this, remember: Keep on writing.
Writing is your freedom, it's a way out, a way of healing. I hope
to visit you all again.

SPEAKING IN CHALKS

Summer's here, and something wonderful is happening at Carnegie. Sidewalk chalking is here again.

Last June posters started going up in the Downtown Eastside. They said, "Come join us on the sidewalks of Carnegie in a celebration of the Downtown Eastside. Spread some colour in the heart of the city. Draw big. Speak your mind. Share your experience of our neighbourhood with sidewalk chalk drawings."

Sharon, a young woman with lots of energy and dedication, was behind the project. First the sidewalk outside Carnegie, at the corner of Main and Hastings, was powerwashed. Then big buckets holding large pieces of coloured chalk were handed out to anyone who wanted to draw a picture, write a poem or just express themselves. There were only two rules: no racism and no obscenity.

I loved this project right from the start. The first day I spent about two hours drawing and writing slogans like "Wimmin flaunt your fat," "Raising kids is work" and "Keep kids out of the sex trade." I wrote out my Balmoral cockroach poem. By the time I was finished I was covered in green, pink and yellow chalk. But I didn't rub it off. I wanted to keep the high feeling. People were working on the sidewalk all around me, sitting and squatting as they worked intensely on their creations. There were many Native people; someone wrote in big block letters, "First Nations First." There was beautiful Native art, poetry and, on the back door of the building, part of a speech given by Martin Luther King, Jr. In all my years of

coming down to Carnegie, it was the first time I had seen this space used by the community for such a positive event. Usually the corner stank of urine and was frequented by pushers and people stoned out of their minds. So this was powerful, taking back our sidewalk.

The chalking went on, one day a week, for the whole summer. Even when it was raining, Sharon would be there in her Levi's overalls, chalking in the rain. Once when it was pouring rain I joined her, trying to hold an umbrella in one hand while chalking with the other. Coloured rivulets dripped from Sharon as she smudged the wet chalk into a sketch of a brilliant sun. One afternoon a bunch of us went to the women's centre a few streets over and chalked on the sidewalk there. Some days my arthritis would be bothering me so much I couldn't get down onto the sidewalk, and other chalkers would offer to help. One day a young man helped me to draw a hopscotch, and some small kids started to use it as soon as it was done.

As I got to know Sharon, who is an artist and activist, I felt really positive about her energy. Many people outside Carnegie can't read or write, but they trusted her enough to ask her to write what they wanted to say. These are people who would never come to a learning centre yet on the sidewalk they felt comfortable asking for help. Here was a unique opportunity for literacy work, in a medium that can be taken anywhere. People were speaking poems and expressing ideas that would never get from their heads to paper, but they were communicating them to the world out on the sidewalks. No one was squishing creativity with criticism. Here were kids and druggies and street women all participating: chalking was *their* project too. Maybe that's where literacy has to begin. The simple act of writing or drawing one's pain, happiness or rage brings a strong feeling of empowerment. Didn't Moses get his instructions on a stone slab?

Trying to capture the chalking experience with words on paper is quite inadequate. Luckily Sharon and some others took

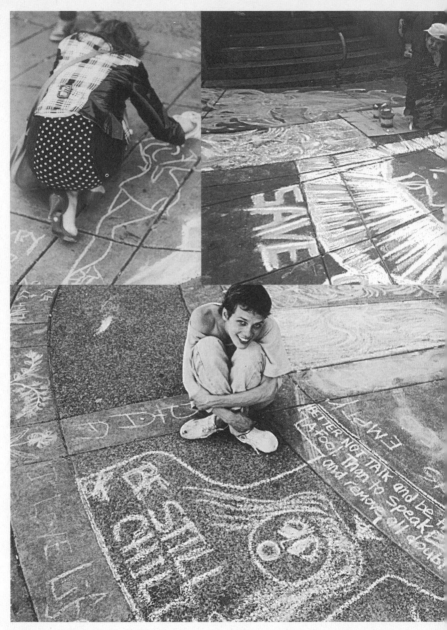

Sidewalk chalking outside the Carnegie Community Centre. Copyright © 1995, J. Vanson and L. Smith.

lots of photos, some of which are reproduced here. The pictures were also made into collages, displayed at the Carnegie Centre and published in the *Carnegie Newsletter*. CTV even filmed some of the chalking. For me the chalking was one of the most exciting grassroots activities I've ever witnessed.

The artists have ranged from 2-year-old children to 75-year-old men . . . There was an 11-year-old blind boy drawing something that resembled a pterodactyl. Just to watch him was extraordinary. He moved like an angel, very determined and very gentle; he was luminous.

—Sharon Kravitz, Speaking in Chalks co-ordinator, *Carnegie Newsletter*, 15 August 1995

When we first try to write or draw as children, a lot of damage is done to us by insensitive teachers and other critical adults. Here on the sidewalk at Carnegie we are rediscovering the budding writers and artists inside ourselves. Here there is no one looking over your shoulder to correct your mistakes. Here there is the freedom to speak out about what matters to you. Here there is the deep, deep satisfaction of working with other people to express the kind of world you want to create, even just for an afternoon.

People who can't read or write feel safer communicating on the sidewalk with chalk than in any school board structure. Talking to people in the Carnegie community about what they would like in the way of education, they want one-on-one tutoring. They don't want to be treated like children. They don't like classrooms where everyone knows they can't read. A woman who I interviewed as part of a literacy survey said, "I would like to be a midwife, I like babies, I would like to learn but I'm slow, I need someone with patience." She explained that she got pushed through high school, passed from grade to grade just to get rid of her. I asked her if she had ever been tutored but she felt she was too slow, no one would have patience. Our school sys-

tem messes up people like her, destroys their confidence. I told her she spoke really well and understood her own needs. I want the learning centre at Carnegie to be there for people like her.

I have started tutoring basic literacy again recently because there's an obvious need for that. This work calls for love, respect and patience. It's good for me; it keeps me focused.

Recently the new co-ordinator at Carnegie also asked me to give a workshop on empowerment for literacy students. I brought a bundle of anti-poverty literature with me and suggested the group set up a table and a bulletin board, to have a visible corner devoted to poverty issues. We put up press clippings, phone numbers for advocates, people's ideas about poverty.

Empowerment for students who are poor comes first of all by helping them understand why they are poor, and that it's not their fault. If they can resist self-blame, learning becomes that much easier.

THE SKID-ROW POETS

One of the most colourful times in my life as a writer was when I was part of the Carnegie poets. All my poems were about social conditions and injustice: writing was a way of letting the rage out. The group of poets I hung out with were not the usual boring academics who write stuff you need a Ph.D. to understand. These were street poets, and they gave me a lot of encouragement.

My Hero, A Welfare Bum

Welfare bum, they called her
As she struggled to raise three kids
She baked, she sewed, she tried so hard
To make a little money
The house she cleaned at the top of the hill

Earned her only twenty dollars
At just thirty-five, she looked old
Her face so lined and wrinkled
She worked and worked
That welfare bum
And raised those little children
The time has come to honour
Such welfare bums.

Poetry reclaimed: back in the hands of the people

At four hours it [an event called Word, Sound and Power, held at the Carnegie Centre] was far longer than most poetry readings, an exhausting, gritty, intense poetry marathon. The audience did not sit politely and listen passively with measured reflection. They cheered and shouted during poems, they applauded after each reader, they called out encouragement and enthusiastic, uninhibited affirmation ...the poetry came out of people's experience, and spoke directly to other people's experience.—*The Ubyssey,* 4 March 1988

Once the Carnegie poets went on a reading tour around the province. We were billed as the Skid-Row Poets. The papers called it the dawn of the new poets. Our first stop was Chilliwack. We were supposed to be billeted and fed there. It was quite a scene. A very nervous man met us and, with his wife and children in tow, took us back to his house and offered us some canned tomato soup and peanut butter and jam sandwiches on white bread. I guess he figured we would like that. The man told us there was an abandoned flat over a store in town. The electricity was turned off, but he said he could get us a key and we could stay there for free. He told us not to tell anyone he had let us in. That sure deflated my ego fast. Our first gig, and we were being treated like bums. I guess the man

thought that Skid-Row Poets would be used to these kinds of conditions. Luckily Bob, our tour manager, had a friend who lived close by, and this guy welcomed us into his home.

HOW I CAME TO WRITE BOOKS ON POVERTY

About twelve years ago I was attending Langara Community College, studying to be a social worker. Every book that we used to study community was written by Americans and about the American philosophy. I couldn't understand why, when we were supposed to be studying Canadian community, there weren't books with Canadian content. But I did start to get an education about why I was poor.

While attending the community college, we were asked to write true stories about the community. I wrote the truth about my community and the instructor said my writing was unbelievable. He was middle class and had never experienced what I described, and he wouldn't believe I was writing the truth. He failed me, and I was devastated. My poetry wasn't poetry and my writing wasn't true writing, according to him. I tried to talk to him but he still didn't believe me. It was very humiliating. Many of the other students were middle class and they had no knowledge of poor people.

Some time later I attended a conference organized by the labour movement, where I met Sandy Cameron, an anti-poverty activist who has since become my friend and mentor. The conference was taking place about an hour's drive outside the city, near a lake, and he had given me a ride there. There were workshops during the day, and in the evening there was a dinner. The dinner was held in a fancy dining room: maroon tablecloths with matching napkins, polished glasses, shining cutlery, fresh flowers on the table. Sandy and I were sitting at a table with a young woman who was one of the facilitators and a number of other union people I didn't know. We were all talking about the issues that had come up during the day.

"I don't think unions care enough about poor people," I said. "They could do more. They could help to get the welfare rates raised."

In a loud voice that I will never forget, the young woman said to me, "How dare you criticize unions? Who do you think paid your way here?"

It seemed all eyes were on me. I stood up, knocking over a glass of water. I felt humiliated, a beggar, a charity case. Raging and crying, I ran outside. Sandy came after me.

"I'm out of here," I said. "I don't care if I have to walk home. They don't own me just because they paid my way. Nobody owns me."

In a quiet voice, Sandy suggested we go for a walk. He is a retired teacher, a tall, soft-voiced, grey-haired man, a true social-ist, a writer and a poet. Sandy had spent many years living with Native people, and as we walked he talked about the importance of trees to Aboriginal people. My rage was like a swirling water-fall crashing on huge rocks.

After a while, Sandy and I came upon a wonderful tree that stretched far into the sky. Its branches formed a kind of umbrella above us. I touched this huge old tree and something went through me like a gift. I felt calm and focused. I said loudly and clearly, "I promise you that I will write about this shit, this classism and poverty. I will write a book." That was the begin-ning of my book about poor women, *No Way to Live*. So my books are the truth; that's the whole point. Somebody has to write the truth.

When I was volunteering at the Downtown Eastside Women's Centre, I was doing advocacy for women and they kept saying that nobody ever listened to them. Nobody believed their sto-ries. The social workers didn't believe them. Nobody asked these women why they thought they were poor and what the solutions were. Their opinions never got heard.

So then I started to ask them, "What do you think you need? Why do you think you're poor? What do you think the solu-

tions are?" I got this interesting pile of ideas from women and I wrote them down and decided I was going to make it into a book of women's thoughts, so the truth would be published. I wanted to have their voices heard, and I wanted my voice to be heard. It came out of frustration—bouncing off that teacher, bouncing off the time the unions told me I had no right to speak.

I got a manuscript together—it was odd sheets of paper, coffee-stained, some handwritten. I didn't have any money. I had a broken typewriter. And I went to Jean Swanson, who is an anti-poverty activist, and said, "Take me to a publisher." She said, "Let me edit it." But these were my women's voices and I didn't want them touched, I didn't want someone "fixing" their words. I was protecting them like a wolf with its cub. So she took me to this basement, which was the office of New Star Books. I had only seen in the movies what publishers were like . . . cigar smoking, etc. It wasn't like that.

I said, "I'm not writing about sex. These are women's voices and you can't edit them, they have to go just as is. And I want each woman to get a rose, and I want the book cover to be in gold." Naive, naive. They were interested, but said I would have to double the length. They said they couldn't give out roses and it wouldn't be laminated in gold—it was too expensive. So I agreed, and from there it took a year for the book to be published.

And then I was thinking about doing a book on homelessness. I've been homeless and powerless myself, so I knew I could talk to homeless people in Vancouver. Before starting the book, I went to groups and workers in Vancouver's Downtown Eastside and asked for their approval to write about this issue. I really had the community's support and was able to interview many people who give services to the homeless, especially through street-level and front-line work. I talked to people living on the streets, to squatters in vacant houses, runaway kids, people in shelters, and families living in rundown hotel rooms where they faced possible eviction any day.

What I set out to do in *Under the Viaduct: Homeless in*

Beautiful B.C. was to shift the blame from the homeless people to the real causes of homelessness: the lack of jobs that pay a living wage; the lack of social housing; our society's lack of political will to end homelessness. My book won the VanCity Book Award for best book written about women's issues. I was the first person to get that award. It was a big honour.

And then I had this small voice in my head saying, "What about the children? Who is listening to them?" So I decided to do a book on children and poverty. I talked to daycare workers and different anti-poverty activists about ideas for the book and how to approach the interviews. Flashing back to my poverty as a child, I remembered feelings of deep shame, intense hunger, daydreaming about being adopted and having nice clothes and shoes, about going to school and having the children like and accept me. If that had happened, I wouldn't be the anti-poverty activist I am today.

I set a number of ground rules, including that the children didn't have to answer any question they chose not to. When I did the interviews, I always phrased the questions in a way that would not embarrass or hurt the children. For instance, I would ask, "How do children that are poor feel in school?" The answers from the children were mostly in the second person, referring to "you," not "I." Using second person seemed to make it easier for children to express their own feelings.

Some children gave me drawings instead of interviews. These sketches tell as much about poverty and its effects on children as the interviews do. Children speak the truth; they're so honest. The title of my book, *A Child Is Not a Toy*, came from one of the children. She said, "Children are not toys like video games and tapes. You can't just pick them up and play with them, then leave them." I wondered, was that how she saw me—interviewing her and then forgetting her? My challenge was to write a book that would make readers want to do something about child poverty, make them work for change.

I've been told, "It's so easy to read your books. It becomes so

clear what the problems are." I'm proud to think that my books are like a stone thrown in a lake—they ripple, they reach people. Some people have said they've cried when reading my books. Others have said, "We've started this project because of your book," or "Your book encouraged me to get active and find solutions." Having the community respect my work is one of my biggest satisfactions.

The hardest thing I've faced as a writer is not being accepted by literary people. It's almost as if my books aren't considered real books. They don't fit the norm so I'm not really considered a writer. In that sense, I'm very lonely as a writer. It's a struggle to stay unpolished, stay on track, not give in to conforming and writing differently. I could take writing lessons and conform to teachers' ideas of how I should write. But I'm an activist, and nobody owns me. Still, resisting is a lonely place; sometimes I find that difficult.

I've been invited to talk about my books to various college and university students. They love my books because there's not a lot of bullshit in them, they don't have to go through reams of unimportant pages. My books are all meat, not a lot of dressing. If all writers wrote like me we wouldn't be pulling down so many trees.

The worst thing that was ever said to me was by an academic who was writing a book about the corporate agenda. I said, "Great, the community could do with reading a book like that. But write it in simple language." He said he would have to write two books: one for the community and one for his fellow academics, because a book in plain language wouldn't be accepted by his colleagues.

In the computer class I've been taking, the teacher told us to use the thesaurus because it would give us "better words to use." I said, "Wait a minute. If everybody turns on the thesaurus when they're writing a book, then all the books are going to sound the same. There will be no unique community voices. There won't be Native voices, there won't be Chinese voices,

there won't be immigrant voices, there will only be white uni-
versity voices, because they're the ones who wrote the the-
saurus." That's another battle.

I like doing readings. There's so much I want to say, teach and
do about the issues and people in my books. When the new pub-
lic library opened in downtown Vancouver I was invited to read
at a public event in the multipurpose room. The new building
looked terribly intimidating, like a Roman coliseum. Security
guards were speaking into microphones and chairs were all set
up in rows like for a church service. I immediately got my
friends to arrange the chairs in a circle and to push the speaker's
desk away. The person who introduced me apologized, saying
they were sorry there was no microphone but it had been stolen.
It turned out to be a wonderful reading. I read about the bag
lady who became my neighbour on Halloween. It touched the
audience; some people were in tears. I read some of the women's
voices from my books, and then some of my stories for children.
Afterwards people from the audience talked about their poverty
and their worries. One well-dressed woman, obviously middle
class, was very distressed. Her face was red with anger and
tears. "This is depressing me," she said. "I've sold my crystal
and my jewellery and now I keep knocking my head against a
wall. They say I don't qualify for welfare." We suggested she
find a group to support her, but in her frustration she didn't
accept any suggestions.

It must be hard to try to maintain an upper-middle-class
lifestyle with no money. There are many of us poor people and
we have no problem hanging out together, but this lady obvi-
ously didn't want to be one of us. For me, socializing over coffee
is where it's at. That's what we did that night after the reading.
We laughed and laughed about the microphone being stolen—
that hasn't happened yet at Carnegie.

Recently I've been hosting a writers' group at Carnegie, mostly for writers from the community, street writers, people who just want to tell a story. We've produced two small books of our thoughts, our poems, even jokes. Some of the street people who did chalking contributed their work. The booklets are nothing fancy, just photocopied paper, but the writers are so proud of their work. There's so much talent for *real* writing here at Carnegie.

The group helps me stay focused on who I am and what the issues are. Everyone counts. If someone has a problem, we'll talk about it. There is one young man who has been on the street for eight months. I said to him, "Do you want to write a poem?" He said, "I can't." "Just tell me about something," I said. And he started to talk about the rain and the sidewalk and it was beautiful. So we finished up writing it and before he left I said, "Why don't you put it on the computer?" And so he did. And then I said, "Why don't you take it down to the newspaper—it's just going to press." So he took it down to the paper, and the next day he had a poem published. And he was so thrilled with it. To me, that's what counts.

So many people have that spark—that tiny little spark—that if you can just encourage them, be it about writing or activism, they can achieve real change. Just a tiny little flame, and you have to blow on it. And if they meet the wrong people, they just get squashed. People only have a flicker and you have to be very gentle with them.

Unmarketable Gold

Writers and artists seldom get rich
The very finest have died in poverty
Should I trade my poems
For a money-making job?
Should I sell my body and soul
To make a corporation richer?

Or should I sit on a river bank
Pen and paper flowing with the tide
As sunsets yellow, turn me into
Unmarketable gold.

I use writing as a tool. I've done more with my writing than I ever did with my body. I've always just been a person at a demo—never a big name or an organizer, just a body and a big mouth. With my books I get to be a literary guerrilla.

When I don't write for a while I shrivel up inside and my energy sags. I feel depressed. I like to write on an old-fashioned, noisy typewriter, although I'm taking lessons on a computer at the community centre now. I feel the adrenaline flow as the words rush from my brain onto the page. As I hear the music of the keys banging out the words, like bullets from a gun, I think, this is the sound of my weapon.

Activist Grandmother, Then and Now

My grandchildren know that I'm an activist. They know about my books, and some of them have brought my books to school to show their teachers. When my granddaughter Melinda was eight, she phoned long distance to tell me a poem of hers had been accepted by a magazine. "I'm a writer like you, Grandma," she said with obvious pride.

I have no money or possessions to leave my grandchildren, but I have something else that is even more valuable: my written truths. I want them to remember me as an eccentric and loving person and as an alternative role model, just as I remember my father's mother Daisy, my own grandma.

DAISY

A friend said to me recently, "You must have had someone special in your life who nurtured you, or you couldn't be the wonderful person you are today." I knew right away that Daisy was that person.

I had very little nurturing from my parents. My mother was pregnant with me when she and my father married. She was already a widow with an older daughter. Perhaps my parents' relationship was good for a few years, I don't know. What I remember are their terrible fights, she with blackened eyes, he bleeding from a knife wound, blood spattered all over the floral wallpaper of our living room. My mother's father had been violent too. When my father finally left my mother, he left me behind with a raging, sick, alcoholic woman who neglected me and abused me terribly, sometimes pressing a knife to my throat and threatening to kill me.

Daisy was my salvation. A picture of her flashes through my mind as I write this, off to the races with her bright red hennaed hair framing her excited, smiling face. She loved to gamble on the horses or the dogs. "Always leave some money in an old purse at home," she told me, "and you'll never be broke." I have always followed her advice.

Daisy was a Jewish woman, a Cockney from East London. She and my grandfather, Walter, had three sons and three daughters and about twelve grandchildren. Walter was a Gentile from the north of England. He had a hip disability that left him with a lopsided limp. He had big, gentle, blue eyes and a soft smile, and he called me Tootsie. He loved his Daisy until the day he died.

"Walter, bring me up a cuppa tea, love," Daisy would call from her bed. Walter would lift the kettle from the wood stove. The two grey cats grumbled as he gently removed them from his knees. He would make a cup of tea for Daisy, three sugars and a bit of milk, then climb the stairs to her with a smile on his face. Half an hour later Daisy would call, "Walter, my tea is cold," and he would smile and take her another one.

When I was a small child my father would take me to visit Daisy. She looked after me a few times when my parents were working, and I lived with her for a couple of years when I was a young teenager. The times I spent there were some of the happiest of my childhood.

Daisy and Walter lived in a dark, narrow, three-storey row house owned by the mill where Walter worked. The mill backed onto my grandparents' tiny back yard, its rusty iron doors always locked. The "chook-chook-chook-chook-a-chook-chook" of the mill never stopped. It went all day and all night. I found the sound comforting.

The house had six rooms and a dark scullery for cooking. The front parlour had an upright piano and a polished table with carved chairs. There was a red rug in front of a fireplace. I never saw anyone eat in the front parlour, or even sit in there. The house

was lit by gas. Each room had a gas mantle that hissed when it was turned down low. Gas lighting is strange. It makes every-thing look unreal, almost locked in time. Daisy always had relatives stay-ing with her—her mother, a large, very old woman with flaming red hair, my Aunt Alice with her hus-band and two children, and later just the children, after

Walter and Daisy Swann, Sheila's grand-parents.

Alice and her husband died. There was even a rumour that Daisy had sheltered a deserter during the war, hiding him in her closet.

The lavatory was out back. It was a square plank with a round hole in it. Piles of old racing papers were stacked up beside it. There was a tank of water way up high and a chain to pull. A trip to the lavatory in the dark was like something out of an Alfred Hitchcock movie. Huge black wood beetles covered the yard and the lavatory itself, and I would hear them go "craaack" as I trod on them. I knew I was sitting on them, too. The huge iron mill doors looked like giants in the moonlight, and Daisy's big wringer, pushed up against them, seemed to be just waiting to grab me. I would clean myself on the rough newspaper and run terrified back to the safety of the house.

Daisy worked hard. She made tea and sandwiches and sold them to the men who worked in the mill. She took in washing, boiling it in a huge copper pot that was always boiling over, sending soapy water all over the scullery floor and out the back door. She would scrub clothes on a scrub board out back, flood-ing the air with the smell of Sunlight soap along with the scent of wood from the mill. She would carry the freshly scrubbed clothes to the huge wooden wringer that stood guard against the

mill's back doors. I would help her, turning the handle as she pulled sheets and towels through the large rollers. As she pegged the dripping laundry to the line, wood beetles scurried away underfoot. Once the laundry was dry, she would iron it using two heavy irons that had been heated on the gas stove. Her washing was spotless.

Come parade time, and there were many parades in London, Daisy would sew red, white and blue banners, hats and streamers, then sell them off a barrow in the streets. Sometimes she made tiny brooches from beads and flowers rolled on wire, and scarlet roses from red paper and silk.

Sometimes when I'd come over to Daisy's she'd be having a cup of tea with someone. The talk was usually about the races: which horse was the favourite and which bookies the best. Sometimes, her hair freshly hennaed and curled with the tongs she had heated on the gas stove, she'd be off to the horse races or the greyhound races. I loved seeing that wild side of her.

Sunday was always a special day at Daisy's. God, how I loved the smell of her Sunday dinners. She would put meat and potatoes in the oven to roast, along with Yorkshire pudding and onion sauce, then off she would go to the pub for a glass of ale with her buddies. I would wait outside, eating one of the large biscuits that the pub sold especially for kids. Sometimes we would have gone to the fruit and veg market on the way to the pub, and I would take care of the big, round wicker shopping baskets. I'd peek into the pub from time to time. Someone would be playing the piano and everybody would be singing and talking, looking so happy and friendly. It was a place for working-class Londoners to meet, socialize, relax. I never saw Daisy drunk. She just loved to be with people. When the pub closed, people would spill out onto the street laughing, heading home for Sunday dinner and a kip (sleep).

When I was sixteen, Daisy got me a job interview as a junior clerk in an office where she used to clean. She gave me my first home perm and lent me her best pin-striped suit, a pair of pearl

clip-on earrings and her black patent leather pumps. I got the job. I guess she didn't want me to work in a factory or a mill, so she got me started off on a different path.

Later the mill and the houses were torn down, and Daisy and Walter moved into a council flat with an indoor bathroom, a bathtub with hot and cold running water and a nice stove. But Daisy still loved to sell stuff, and she would go down to Brixton Market with her barrow.

When I came to Canada forty years ago, I lost touch with Daisy. Walter had died by then, and she was living with two of her grandchildren. I just had to get away from the pain of my family, and I lost touch with everyone. I don't even know when my grandmother died.

Thank you, Daisy, for showing me how to survive and how to accept responsibility, and most of all, how to break the rules and be a little wild sometimes. You were the one who nurtured me, and I'm sure you loved me. As I loved you.

HOLD YOUR HEAD HIGH

I really enjoy being a grandma. When my grandchildren visit, the rule is that we've got to have fun. Sometimes we go to the beach and look for interesting driftwood and shells and anything else the ocean has thrown in with the tide.

One night my grandchildren Sammie and Conrad came for a sleepover. My apartment is really small, but I keep lots of extra blankets and pillows in the cupboard for these welcome visits.

In the morning I said to the kids, "Let's go for a walk." The cloudy grey skies threatened rain, but we decided to take our chances.

As we were sitting having ice cream on Robson Street, somehow or other the topic of skin colour came up. Sammie and Conrad's father is mixed race, and their mother, my daughter, is white. Sammie, six years old with black soft curls falling around

her face and huge brown eyes, said she thought her skin was a kind of a tan colour. Conrad is eleven now, and so tall. He asked Sammie, "What colour do you think I am?" Looking at his green eyes and shiny straight black hair, Sammie thought for a minute and then said, "You are a honey colour." Then Sammie turned to me, her short, chubby, blue-eyed grandma, and asked, "What colour is your skin?" Both kids awaited my answer. "I'm a kind of cheesecake colour, I think," I said. They laughed.

After our ice cream we walked down Georgia Street to look at the yachts in the harbour. We came out behind the Bayshore Inn, a big expensive hotel near Stanley Park. Walking through the grounds, we saw people doing the expensive dining thing on the other side of the windows.

Conrad got a bit scared. "Are you sure we can be here? Won't they send security?" he asked anxiously.

This pissed me off. Impulsively, I said, "Let's go in." Sammie and Conrad looked dubious. "Just hold your head high and be proud of yourself," I told them. "Then you can go anywhere."

I was secretly amused to see the kids hold their heads up as high as they would go. I have taught my grandchildren lots of anti-poverty stuff, and I felt instinctively that it was important to do this.

We walked through the lobby, observing everything. Sammie was impressed with the women's washroom because it had boxes of Kleenex and a phone. In one of the rooms off the lobby, an artist was having a showing. Security guards stood in the doorway, and bowls of nuts and glasses of wine rested on tables. There were no children or people of colour in the room.

"Let's go and look," I said. Conrad started to take off: "No way, Grandma." Firmly, I said, "Yes." We three walked past security and into the room.

As we looked at the paintings, Conrad said, "Me and Sammie could do better than that." Then he made me laugh by saying, "Don't eat those nuts. Everyone has had their fingers in them." Sammie walked up to the table and took one tiny pretzel.

As we left I signed the guest book. The kids did too, Sammie's six-year-old scrawl taking up half the page. Next I suggested we sit for a while on the huge couch in the lobby. The kids got into it, starting to enjoy playing at being rich. As we left, I said, "Thank you, goodbye," to the doorman, and the kids did the same thing.

We had to walk up a long hill to get home. My back hurt and my knee was sore. Laughing and happy, Conrad and Sammie decided to get behind me and help push me up the hill.

Sammie called me a few days later.

"How did you enjoy Sunday?" I asked her. "Was it fun?"

There was a pause. Then she said, "We were only pretending to be rich, weren't we? We're really kinda poor, right, Grandma?"

Just before we hung up, Sammie said, "Holding my neck up for so long gave me a sore neck, Grandma."

Sheila and her grandchildren enjoying a day at the beach.

Sheila: portraits of an activist.

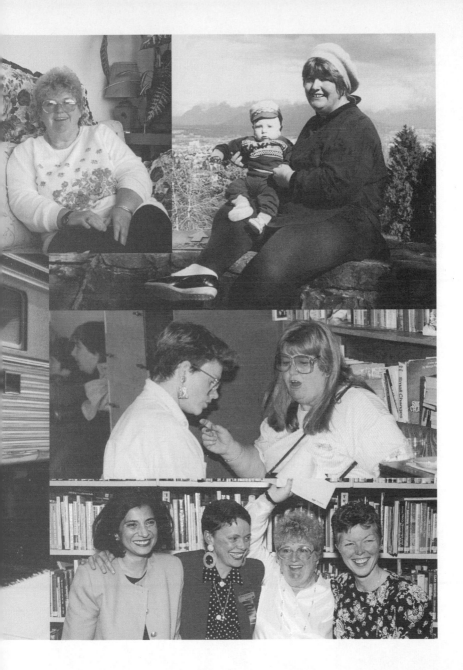

LETTER TO MY GRANDCHILDREN

Dear Ones,

When each of you was born, I was so happy, so excited. My genes, along with those of others, will live on in you.

The world we adults are turning over to you is really messy. Generation after generation has passed on untruths and injustices: racism, sexism, war, poverty, greed, pollution. This list is very long. But you and your children will have a chance to build a better world and to take better care of the planet.

I believe with all my heart that the children of the future will achieve a true "Peace on Earth." I won't live to see it, but knowing it can happen gives me joy. I feel so hopeful when I talk to you, my dearest grandchildren. I know you will be seekers of truths.

With all my love,

Grandma

Activists Share
Their Stories

I'm an activist and nobody owns me. Being a London Cockney, I've had a survival instinct since I was a kid, sleeping on the streets to escape violence at home. I've always known to resist and to question, starting in Kindergarten when I refused to wave a little flag for the Queen of England—who was she, that I had to wave a flag to her? Ever since then, I'm the first to jump in and take action. When you're an activist you're always looking for solutions, you don't dwell on the problem.

I've been fascinated to know what makes some people activists, while others from similar backgrounds may become substance abusers or simply accept injustice. When I decided to write this book about anti-poverty activism, I also interviewed a lot of other activists in my community. I really wanted to know: Is there an activist gene that some of us inherit? Where does the urge to make a difference come from?

I asked activists a few straightforward questions: Where did you grow up? What was the first issue you got involved in? What other issues have you been dedicated to? Is there a burning issue that you haven't dealt with yet? Many of the interviews were quite lengthy—they were taped and transcribed—and only excerpts of them are reprinted here. These are spoken snapshots, not complete life stories. In some cases I was given photos to use along with the interviews.

There are no easy answers regarding what makes an activist, but there is much inspiration to be drawn from these stories. In our midst there are many, many people who in large ways and small, for decades and lifetimes, contribute locally, nationally and internationally. As long as we preserve the right to speak out, there is always hope for change. As long as we raise hell for

political reasons we keep the door open. In their own ways, I see each of these activists as protecting that freedom by still raising hell.

SADIE KUEHN

I have known Sadie for over ten years and I have a great deal of love and respect for her. She has served on the Vancouver School Board and also ran for city council.

I grew up in the deep south in an African American home with Jewish godparents. I was raised by my grandmother, who was a social activist, an educator, and also worked as a seamstress. She had strong roots in her African traditions and wanted her grandchildren to know where we came from and our place in the world. She had a great influence on me as a person.

Growing up as a woman of African heritage in the segregated South, I couldn't take on the issue of being a woman without taking on the issue of being a woman of colour. My family may have had some resources but those resources were limited by the fact that I was Black. I was in a second-class position regardless of how clever or how good I was. Therefore as a feminist I am clear that class issues, race issues, issues of sexual orientation and differing abilities are all connected: gender is not the only issue.

When I was thirteen I was involved in voter registration in the South. I was the youngest person involved. We travelled around helping people of African heritage get registered to vote, and we had to do literacy training, we had to teach people how to read. There were barriers against people who couldn't read. Whites would ask a Black person to read from Shakespeare and if they couldn't read that the person couldn't be on the voters list. This was around 1962. It was an exciting time for me. It didn't feel scary at the time but when I look back on it now as an adult it seems quite scary. We were supporting people who had been disenfranchised, enabling them to vote for the first time.

At sixteen I graduated and decided to join the domestic peace corps. Historically they had never taken anyone that young or anyone of African heritage. I trained as a bail bond person, getting people out of jail. I chose to go to Miami but found I couldn't work in the field I was trained in, because no women were allowed in the jails. I ended up moving out of Miami into a migrant labour camp, working in what was called an enrichment program for children. Many of the people I worked with were women whose partners may have been in jail, and they were living in dire circumstances. The migrant camp had no running water. The parents were working in the fields or off in jail and we provided the children with a place where they could get a meal and some education. One of the things I was committed to was allowing these children to experience a variety of things which they would otherwise never have a chance to do before winding up in the fields or orchards with their parents. I had a government car and I would take a mixed group of kids to places like the Miami airport, the beach, the Everglades. I got into a lot of trouble from my director because people complained about the racially mixed kids travelling together.

I left the United States in 1968 and moved to Kitimat, British Columbia, with my partner, who had a teaching job in the high school. I got a job as a part-time counsellor at the school but within a couple of months I got pregnant and I was told my services were no longer needed at the school. This was 1968 and teachers were not allowed to wear pants or to teach with their husbands or to be pregnant. The kids at the school were not allowed to see you pregnant! I came out of an Afro American tradition where women always had to work, whether they were pregnant or not, so this was some shock to my system.

Living in the North in an environment where women were very isolated and had very few options was challenging for me. It was a one-industry town and women were not allowed to work in the aluminium smelters; nor were they part of city politics. I did a lot of work with women around issues of physical

and psychological abuse. Those were things people didn't want to talk about.

In the late 1970s I was living in Kamloops and I started the first women's caucus there. I had been active in the New Democratic Party since I first came to B.C., working on campaigns in the community. When I came to Vancouver I got really involved in the women's movement, including at the Vancouver Status of Women. I was one of the few women of colour being published in feminist publications in Canada, and felt that I should be supportive of other people becoming empowered and involved in writing. I was one of a group of women of colour who laid out an action plan for how to involve a broader section of women in writing for *Kinesis*, the Status of Women newspaper. I also became one of the founders of the political magazine *New Directions*.

Equity for all people in our society is my back-burner issue. For me it is unconscionable that as the second richest country in the world we have people forced to live on the streets, we have families that cannot afford decent housing. We have older women and men forced to live without dignity and young people who are not guaranteed a meal a day and who feel they have no future. I believe in political action, and equity is an ideal I will continue to work toward.

MARGARET PREVOST

I've known Margaret as an activist in the Downtown Eastside for many years. She is an ex-vice president of the Carnegie Association and currently is president of the Downtown Eastside Local 135 of the United Native Nations. She has recently taken up photography and uses photographs in her activism.

I grew up in Alert Bay and Campbell River, on Vancouver Island. The welfare system took us away from our parents and the reserve and I lived in thirteen foster homes. But my grand-

mother raised me for ten years and she is the woman I respect the most. She was an Elder and she always cared for me and my ten brothers and sisters until the day she died. She was there for the neighbours and she was the grandomother of the reserve. Everybody respected her. She is the woman I relate to the most.

The issues I've been involved with are disability issues, the national aboriginal network of people with disabilities, the *Carnegie Newsletter,* welfare rights and community relations in the Downtown Eastside. I fought for wheelchair access to CRAB Park and for years have fought to get curbs made wheelchair accessible.

Since my accident my band has funded my wheelchair so I could participate in wheelchair sports. And they funded my basketball trip to France.

If people need my help, I am there for them. I don't advertise but they know I'm here in the Downtown Eastside. That's where my priorities are.

LORNA BOSCHMAN

I've known Lorna for years and have worked with her on two videos, one on fat and one about welfare. She works through Video In, in Vancouver.

I was born in a small town in northern Saskatchewan called Carrot River. My parents were both working and my grandparents, who are Mennonites, took care of us when we were kids. I grew up in Sarnia, Ontario, next to the U.S. border, and the first demonstration I participated in was against the Amchitka nuclear testing in Alaska. In high school I remember our Latin teacher was really sexist, acting as if everything about men was great and everything about women was stupid. I got all of the girls in the class to go on strike and refuse to participate. We made little protest signs and wouldn't answer questions or anything. The teacher apologized and I got pegged as a ringleader.

When I finished high school, I moved to Toronto and got involved with feminism there. I joined a group called Wages for Housework, an international socialist feminist group, and I was involved in the gay and lesbian communities, primarily as an artist. I've been working in video for the past ten years and have addressed a number of different issues using video. *Scars* features four women talking about slashing themselves as a way to control their pain. *Our Normal Childhood* is about child abuse: me talking about being physically abused and another woman talking about being sexually abused. I've worked on three videos about fat: *Fat World*, a made-for-TV video about the general conditions of fat people in Canada; *Big, Fat Slenderella*, a video about and against dieting, and *The Seven-Day Poodle Diet*, a full-length feature. I also worked on a welfare rights video which was part of a media literacy training program for the People on Welfare group at the Carnegie Community Centre. The group decided on script ideas and what they wanted in the video— they had the control and I did the video training.

I've done a lot of video work about my partner, Persimmon Blackbridge, who is a sculptor and a politically involved artist. *Doing Time* was a video of a sculptural work Persimmon did with four women who talked about their experiences in prison or jail (Michelle Kanashiro-Christiansen, Geri Ferguson, Lyn MacDonald and Bea Walkus). Then I made several videos about the work of Kiss & Tell, a lesbian sex art group that Persimmon is part of. *Drawing the Line* was based on their first show, where they asked viewers, Where do you draw the line, or do you draw the line, on lesbian sex photos? After that came *True Inversions*, a video which was part of Kiss & Tell's multimedia performance piece called True Inversions.

The issue on the back burner for me is electoral politics. A lot of people who are left-wing supporters are feeling really frustrated and don't vote in either federal elections or municipal elections. It makes me feel like there's practically no one representing me. I would like to be more involved in electoral politics

but I just don't have the time. I feel I can do more through my work as a video-maker, because that is a very powerful way of getting my message across and opening people's minds to a new way of doing things. Also my work is a great way to learn about how other people live, and it prevents me from having an isolated existence.

NADINE KING CHAMBERS

I met Nadine at a conference in Vancouver. As well as being an activist, she is a writer and storyteller.

I grew up in Jamaica, that's where my roots are, though we moved around to other countries. I come from a family of artists, writers, newspaper editors. My grandfather was very much part of the movement for the West Indies to gain independence from Britain.

One of the first memories I have that relates to activism was one day when I was walking home from school. I took a route I hadn't taken before and left behind the nice neighbourhood with the manicured gardens that I usually walked through. I ended up walking into a forested gully and listening to the sounds of traffic becoming dimmer and dimmer. I came out in a neighbourhood full of poverty, seeing other children who were like me but not like me. My mother was scared to death when I finally got home and I remember a real sense of dismay, asking myself, What is this place and why? I was a child but I really felt there was something very wrong with this picture.

Racism is a daily event in my life. Activism for me is just being healthy; that's the most political thing I can do, because of the forces that are working against me as a black woman. The bottom line is that I should not even exist and if I do exist I shouldn't be in a healthy frame of mind or body. There's a history of injustices around health that have been perpetrated against people of colour, specifically black people, around lack

of health care and experimentation, and now AIDS is becoming an epidemic in a lot of third world countries.

Part of my community is the gay and lesbian community and the latest issue I'm involved with is AIDS. One of the big issues for me regarding AIDS is that when pharmaceutical companies do all kinds of testing of new drugs, often people of colour and women are not included in those studies. The white male bodies receive all the attention while people in my community may respond differently to HIV, but we're not part of the studies.

I prefer to work locally. I work with a black AIDS network. Women's health is also an important issue; I could easily get involved in basic health 101: food, shelter, emotional health, empowerment and equality.

JIM PENCE

I have been to many demonstrations with Jim, who like me is an unpaid advocate who can be depended on. He told me about his years of volunteer work and the many issues he has been involved with.

I was born on September 28, 1928 in Richmond, Missouri, a town in which the coal mine had closed. All the male members of my family had worked in the mines and my mother had worked in the company store. My maternal grandfather was severely injured in a mine accident. I remember very clearly the extreme poverty of my classmates and also of the widows and orphans, as there was no workers' compensation for injuries or death.

The first issue I was involved with was civil rights, during the Vietnam war protests. Another early issue was supporting farm workers in California. I was a social worker for the Department of Social Service in Los Angeles and served as shop steward for the union. When I moved to northern California, I served on the mayor's committee for affordable housing and on the local

poverty council. I was appointed by my Bishop to the Northern California Ecumenical Council and with them went on a tour to southern Mexico, Nicaragua and Cuba. Over the years I took part in many protests, including demos against shipping arms to El Salvador and for a freeze on nuclear weapons.

I moved to Vancouver to retire. I've been involved in peace marches, opposing Free Trade and NAFTA (North American Free Trade Agreement), supporting the end of the boycott of Cuba and many other issues. I've continued to do non-paying work for ecumenical organizations and for End Legislated Poverty. The most nagging unresolved issue for me is the mis-distribution of wealth. My faith teaches me that all things belong to God and must be shared equally with all His children everywhere.

SVEND ROBINSON

I interviewed Svend at the Sechelt Writers Festival in British Columbia, where he showed up for my early morning reading and took time from his busy schedule to talk to me about his roots as an activist. He comes from a family of activists. His dad was always a socialist and his mom was involved with Voices of Women. Svend has been the Member of Parliament for Burnaby since 1979.

I was born in Minneapolis in 1952 and my family lived in a housing project. I spent a couple of years there and then my family travelled all over, living in different states and in Denmark until I was fourteen. My parents decided they didn't want to live in the United States anymore because they didn't want to pay taxes to support an immoral war in Vietnam. So we moved to Burnaby, British Columbia, and that has been home ever since.

As a small boy I remember getting very angry about how black kids were treated. For example, when we were living in Missouri in a really poor area, blacks were treated very harshly and

unfairly, and I never understood this. I was a kid and I didn't understand why you would treat someone differently because of their colour. When I was in grade three, in a housing project in Seattle, Washington, the teacher asked us all to swear allegiance and I refused because there wasn't liberty and justice for all. I'll never forget that as long as I live, because they wouldn't let me stay in the classroom. But my parents supported me totally on that and they have always been supportive of my activism.

Another memory that stands out was when I was in grade seven in a school in Alberta. I won an award for being the top student in the city and there was a special school assembly where the principal was going to present the award. I was up on the stage and he said something about how proud they were of me and then he went to shake my hand. I said quietly, "I won't shake your hand." "What do you mean?" he said. I repeated, "I won't shake your hand," and he ordered me to shake his hand but I refused. One time earlier this principal had said that he would never shake hands with an Indian—there were lots of Indians in that area—so I said to him up on the stage, "I won't shake your hand because you wouldn't shake an Indian's hand." He was stunned; he didn't know what to do, so he just handed me the certificate, but he hated me after that.

When I quit university at age eighteen I worked as an underground goldminer in a community in Ontario. I was working three thousand feet underground and got paid as a miner but I also got a coffee house going for the young people and worked with Native people at the Native Friendship Centre and showed films to the miners in the bunkhouses. I got fired from that job because I complained to the Ontario Human Rights Commission about discrimination against Native people. I was a member of the steel workers' union at the time and they supported me and filed a grievance against the mine manager.

I've been involved in a lot of issues over the years: justice issues, human rights, aboriginal people's rights, poverty issues, environmental issues. I was arrested at Lyle Island with the Haida

people in 1985 and found guilty of contempt of court. I also got thrown out of China for meeting with families of political prisoners from Tiananmen Square. I supported the Palestinians in the occupied territories. I support gays and lesbians and people with HIV. I was the first gay person to come out publicly in the House of Commons in 1988. I've always been a peace activist and I oppose cruelty to animals, experimentation on animals.

All the issues are linked. Kids living in poverty is a major issue for me. There are 4,000 kids that die every day on this planet from preventable diseases and hunger, yet look at the obscene amount of money we spend on weapons.

LIBBY DAVIES

I've known Libby Davies as an elected official at Vancouver City Hall for many years. When I launched my book Under the Viaduct, *I held the event right under the viaduct and Libby came and spoke about solutions to homelessness.*

In the 1997 federal election, Libby Davies was the New Democratic Party candidate in Vancouver East. Her campaign literature said, in part: "Not voting is hazardous to our community's health. A poor turnout will tell the Liberals that cutting health care and education is okay. While corporate profits go untaxed, 700,000 more children and their families have been pushed into poverty." Libby won the election.

My childhood was spent in Cypress, in the Middle East, when there was a civil war going on between the Turkish and Greek Cypriots. My dad was in the British army and we lived all over the place, including Malaysia and Germany. But I didn't come from a typical army family, because my parents voted Labour and wherever we lived my parents always made a point of being part of the local culture and developing relationships with local people. As kids my sisters and I always had local friends. Our family was socially active. We talked politics at the dinner table,

and wherever we were in the world, we listened to the BBC (British Broadcasting Corporation).

I was always very rebellious at school because I had my own sense of direction about what I wanted to learn. The learning environment I was in was very conservative, very dull, very conformist, and I can remember from an early age feeling frustrated, boxed in.

The first social issue I worked on as an adult was fighting to get the Downtown Eastside recognized as a neighbourhood. In the early 1970s it was considered skid row and the city didn't recognize it as a community. When I was nineteen, I, along with a group of other young people, started a low-cost food store in the community health clinic in the Downtown Eastside. In 1973 the Downtown Eastside Residents' Association (DERA) was formed and started dealing with housing, slum landlords, tenants' rights in hotels and rooming houses, getting the Carnegie Centre opened, etc. We fought to clean up beer parlours and to get a liquor stored closed and to get decent social housing, not just tiny boxes without cooking facilities.

When I got elected to Vancouver city council as a member of COPE (Committee of Progressive Electors) in 1982, I became very involved in the peace movement. We were able to put peace on the municipal agenda and to push for the city to be an ally to the peace movement. That was the year that Bill Bennett and the Social Credit brought in their restraint program which began the whole solidarity fightback. I was just one person in thousands involved in that coalition but I saw my role as getting supportive motions through city council.

I ran for Mayor of Vancouver in November 1993 and didn't win. But I am an activist, I always have been and always will be, in whatever work I do. I want to focus on building a strong community coalition that can bring together all of the neighbourhood interests. Something that I really care about and want to work on is the issue of prostitution. Sex trade workers are marginalized people who are often scapegoated. One of the

Community Activists: (*Clockwise from top left*) Nadine Chambers, Sadie Kuehn, Lorna Boschman, Svend Robinson.

(*Top*) Margaret Prevost. (*Bottom*) Jim Pence.

most moving experiences I ever had was when I attended the
memorial service for Cheryl, a Native woman who had been
raped and killed in the Downtown Eastside, and her body was
mutilated and scattered. We all went back to the Carnegie
Centre and the other politicians left but I stayed on that after-
noon. I kept looking at this woman's two little boys in the front
row and thinking about how her life had been destroyed by so
many factors. While I was still on city council I was looking at
laws that would not victimize women that work the streets but
would also take into account neighbourhood concerns.

Whether there's an activist gene in me is hard to know. Who
I am comes from my upbringing and the attitudes that my par-
ents had at home. Regardless of whether it's a gene or not, it's
something.

ALICIA MERCURIO

I met Alicia at the Carnegie Community Centre, where she has
been Education Programmer since 1988. Along with the life
experiences recounted here, Alicia shared many more stories of
activism, including her work with the Canadian Human Rights
Commission in Edmonton and with First Nations men at
Matsqui prison in British Columbia.

I wan born in San Francisco in December 1933. My parents had
lost their home and a restaurant in Hollywood during the
Depression and had moved to San Francisco, where my father
got a job in a garage. My early life was set against a background
of poverty, bitterness, anger and World War II. My brother, who
was twelve years older than I, died on a ship at sea when I was
ten. Mother's heart was broken and she rarely left the house
from then on. I did all the shopping and errands and every sum-
mer I worked picking fruit to earn money for school clothes. As
a teenager I also worked as a Candy Girl in our neighbourhood
theatre on weekends and several nights during the week.

Finances were always a cause of tension in our home. In hindsight I wonder if we might not have had such a struggle if less money had been spent on booze and my dad's night-life.

The end of the war was a jubilant time in San Francisco, though not in our home. The initial meetings of the newly formed United Nations took place and as a student I got to observe the wonderful array of strangely clad people from all over the world who gathered at the UN. The UN promised equality to all and no more wars, and this made a big impression on my life. My father seemed to resent any group of people making progress in society, be they blacks, Jews, women, etc. My mother was from a mixed ethnic background and she had more liberal ideas about other races, but she was too weak to overcome my dad's racism.

When I was in high school I really loved blues music and, with a small group of girl friends, I hung out at record stores and attended concerts and got totally immersed in music. Our group had the chance to meet celebrities like Sammy Davis, Jr., Ella Fitzgerald, Dizzy Gillespie and Duke Ellington. Soon I had a crush on a classmate who was black. Even on group dates we weren't safe from racist police who would grab me and call my parents to let them know who I was with. I was severely beaten by my father, and my mother was berated for my behaviour. After other serious conflicts at home, I changed high schools, left my old friends and abandoned my love of R&B music and took refuge in the Catholic church. By senior year I had a "nice" Italian boyfriend (my father totally embraced the Italian half of his heritage) and after graduation I got my first job and became engaged. My fiancé left for the war in Korea and some time later I decided to break the engagement and enter a convent. I entered a teaching order and was sent to Arizona to teach.

I taught in many places, primarily in poor neighbourhoods where the majority of my students were African American or Mexican American. I began to become more aware of politics. Racism was a major issue, as was the Vietnam war, and I

became aware of how right-wing and conservative the religious order I belonged to had become. When the order closed many of the ghetto schools while opening new schools in more affluent neighbourhoods, I decided to leave. It was 1969, I was a thirty-three-year-old virgin who had been in the Catholic order for twelve and a half years. I left with one set of ugly clothes and the $200 I had brought as a dowry when I entered.

The scene in L.A. was beads, LSD and anti-war protests. I got involved with Bootstrap, an African American self-help group, and took part in anti-war demonstrations and other activities. By the end of my first year "out" I was married, and my partner and I were working and saving money to move to Canada. We moved to Alberta in 1968 and I got a teaching job. My partner and I became active in the Calgary Committee to Aid War Resisters.

In March, 1970, I gave birth to our son, Casey. Our house was full of draft dodgers, puppies, and now a baby. I was teaching at Mt. Royal College and at night school, but by September we had all moved to a tiny cabin on an old homestead in the Shuswap Lake area in British Columbia. I was there for seven years with no running water, no hydro and no phone until the last two years. I got to know First Nations people from the nearby reserves, and got involved with starting a women's centre in Salmon Arm. I was one of the original outreach workers on a project focusing on women and First Nations youth. This put me in much closer contact with people on the reserves and made me more aware of the enormous effect of racism on First Nations people. Our women's group was a member of the Okanagan Women's Coalition and of the B.C. Federation of Women.

After a number of years working in Salmon Arm, I was offered a job developing an education program for the Okanagan Indian Band in Vernon. I moved to Vernon and while living there (I had left my husband), I became the co-ordinator of the Okanagan Women's Coalition. The coalition sponsored the first symposium on human rights, which gave birth to the B.C. Human Rights Coalition. I was also involved with a group

called the Federated Anti-Poverty Group of B.C. In the spring of 1980 I was offered a job with the Human Rights branch of the provincial government, and I moved to Vancouver with my son. Becoming a Human Rights Officer was a wonderful experience for me. I was actually earning a living doing the work I had always done as a volunteer.

The struggle to end racism and to bring about universal equality and peace has been my life project.

CLAIRE CULHANE

My introduction to Claire was at a demonstration opposing the demolition of good housing in Montreal in the early 1970s. I met her when she was being forcibly removed by the police, who had her by the arms and legs. It scared me; I had just recently started participating in demonstrations.

A few years before her death, at age seventy-seven, Claire responded to my questions to activists with a written response, some of which is reprinted here. For years she fought Canada's involvement in the war in Vietnam; later she became known internationally as a prison rights activist. A book on her life, One Woman Army: The Life of Claire Culhane, *by Mick Lowe, was published in 1992. In 1995 Claire received the Order of Canada for her commitment to social justice.*

I was born in Montreal in 1918 to Russian-Jewish immigrants who were part of a mass exodus of Jews from Russia during the 1905 revolution. My brother Jack was five years older. We lived in Hochelaga, in the East End of Montreal, a French section. We were the only Jewish students at Maisonneuve School and we were subjected to more than the usual anti-Semitic discrimination from other kids. At Christmas time, we were rejected because we didn't believe in Jesus Christ. At Easter, we were sometimes pelted with rocks because "the Jews crucified Christ." I was ten years old before I realized the French word for Jew was

Juif, not Maudit Juif (goddamn Jew) which was the only way I ever heard it said.

The first issue I recall happened when I was about ten. I asked my mother, in front of Sunday dinner guests, why, when we objected to being called "Yids" and "Kikes," was it all right for them to call non-Jews "Golochem" (priests) and others "Schvartze" (niggers). The answer was a slap across the mouth and being sent to my room.

Other issues I've been involved with:

During the Spanish War (1936–38), I joined the Young Communist League, which was active in helping Canadians returning from Spain to get settled. In 1939 I helped to try to organize a union, the Association of Office Workers, during the Maurice Duplessis "fascist" period in Quebec. Between 1940 and 1967 I got married, moved to Vancouver, had two daughters, separated, moved back to Montreal with the children in 1955 and was too busy working to support the family to be involved in social issues.

In October 1967 I accepted a one-year appointment as Administrator of the T.B. Hospital in Quang Ngai, South Vietnam, but left in March 1978 when American troops took over the hospital to use it as a military base. When the Department of External Affairs refused to allow me to present my report, which described what Canada was doing in Vietnam, I did a ten-day fast on Parliament Hill. In December 1969 when the My Lai Massacre was exposed, I and Mike Rubbo, a National Film Board film-maker, spent nineteen days in sub-zero weather on Parliament Hill to expose Canada's role in Vietnam. In 1972 my book, *Why is Canada in Vietnam? The Truth About our Foreign Aid* (NC Press), was published. It included the twenty-five-page report which the Canadian government had tried to prevent me from releasing.

In 1976, I visited a prisoner at the British Columbia Penitentiary. I have continued visiting prisoners since that time, locally and nationally. I've helped set up Prisoners' Rights Groups, and

have attended local, national and international conferences for
the abolition of prisons and written three books: *Barred from
Prison: A Personal Account* (Vancouver: Pulp Press, 1979); *Still
Barred from Prison: Social Injustice in Canada* (Montreal, Black
Rose Books, 1985); *No Longer Barred from Prison* (Montreal,
Black Rose Books, 1991). I maintain a steady correspondence
with prisoners and their families, as well as with various criminal
justice officials across Canada.

The back-burner issue that isn't yet resolved for me: the
whole world.

LARRY LOYIE

*I met Larry many years ago at the Carnegie Learning Centre.
He is a soft-spoken, white-haired First Nations man who is a
playwright and is dedicated to literacy.*

I grew up in northwestern Alberta in a small village called Slave
Lake. For the first ten years I lived with my family, then my
father went to war and we children were taken by missionaries
and put in residential school. We had no more family life, and
we weren't allowed to speak our language. Mostly what I
learned there was how to pray and how to work and how to
sing in Latin at Mass. We got to go home once every school
year, though many children stayed the whole year. It was basi-
cally worse than jail. Everything that was natural to a small
child was a sin and we got punished for it. I didn't know about
sin and heaven and hell until I got there, and then I was always
getting beatings from the nuns. I ran away twice and both times
I was caught and severely beaten. After that I started reading
everything I could get hold of. There were classics like *Huckle-
berry Finn* but there was exactly nothing about Native people.
We were punished for the fact that hundreds of years earlier
Jesuits had been killed by Native people. I lost all feeling about
my Native heritage. I guess I existed from day to day.

I left the Mission when I was fourteen and went to work on a farm. Later I worked in surveying and later, in British Columbia, I worked in a sawmill. I was involved with the Native Brotherhood, and worked in the herring fishing industry in the early 1970s. I quit fishing after one of the boats I was on sank and I survived in a life raft. The boat ahead of ours disappeared with all six people aboard. The ocean was pretty rough and I think thirteen or fourteen boats sank that year. I was on the negotiating team fighting for the safety of the men. At the time the head of the union said, "If they can't look after themselves, that's their problem."

Later I got a job in Alberta with the Native Counselling Services in the prisons. The majority of people in prison were Native, so I had a lot of work to do. I fought for the young people in prison to be allowed to go to school, rather than being sent to bush camps to work. There was a lot of racism in the prison, the same as in the residential schools. Prison authorities didn't want to have a Native organization in the prison system, they didn't allow sweat lodges. I went to a lot of prisons in Alberta.

At the Carnegie Centre I started doing creative writing and literacy work. I was part of the group that produced the book *The Wind Cannot Read*, in which new learners from across Canada told their stories. Every province had their own section in the book, and I was responsible for British Columbia. I travelled throughout the province to encourage writers. In total we collected over a thousand pieces for this international literacy book. Now I'm writing plays about residential schools, letting the public know what we children went through. I'm also researching a play about how the media portray Native people.

The main issue on the back burner for me is teaching non-Native people the truth about Native people.

SANDY CAMERON

Sandy has been working on social issues for thirty-five years. He has been my friend and mentor in the Downtown Eastside com-

munity for many years. I asked him recently to talk about the fasting he has done as a form of political protest, and also what makes him an activist.

I have been privileged to take part in two political fasts in Vancouver in the 1990s. The first one was for seven days in April 1993 to protest the hunger awareness week declared by an American charitable-style "Taste of the Nation" event. This event promoted food banks for the poor and gorging for the wealthy. It was misguided because it didn't speak to the government policies that have created great poverty as well as great wealth in Canada. It is justice citizens want, not charity.

The second fast was from March 25 to April 1, 1996. It was a national Fast for Fairness, and involved hundreds of people across Canada. It was a protest against the abolition of the Canada Assistance Plan (CAP), which guaranteed ordinary Canadians the right to income when in need, and the implementation of the Canada Health and Social Transfer (CHST), which ended national standards for social assistance.

The CHST places Canada in the position of breaching international human rights law as expressed in the Universal Declaration of Human Rights (1948), the UN Covenant on Economic, Social and Cultural Rights (1976), and the UN Convention on the Rights of the Child (1989), all of which Canada has signed.

When I started the first fast, I wondered if I could do it. I'd never fasted that long before, but I had read about it and found that people can fast for quite long periods of time without too much danger as long as they're drinking lots of water and juice. So actually I didn't have any apprehension, but by the fifth day I started feeling a little bit weak. I think that was more psychological than anything else. I thought I should feel weak after five days of not eating so I did. The second fast was eight days. I realized that I didn't have to feel weak after five days—that it

was quite all right. In fact I think I could fast for twenty-one days without too much difficulty.

On the second fast, a woman came up to where I was sitting on the steps of the library with a sign that said "Lament for a Nation."*

"Why 'lament for a nation'?" she asked.

"Because we are a country which is losing its human rights, because more people are becoming poor, because there are many unemployed people and this is a reason to lament," I said.

"I know exactly what you're talking about," she said. "I'm from the United States and we see a lot of poverty and homelessness. And I wish you well in this fast because we have to fight this."

So we shook hands and away she went.

A fast is an expression of solidarity with those who are hungry. It is a way of grieving for the anxiety and paralysis of many Canadians in the face of growing injustice. We see long food-bank lines and we get used to them. We see more homeless people and we get used to them. We know increasing rates of poverty and unemployment cause increasing rates of family breakdown, property crime and youth alienation, and we get used to it.

A fast is an act of protest, a time of reflection, and an act of penance for ourselves and our political and economic leaders who have lost touch with the Canada for which men and women died in the Second World War. A fast can empower us when we feel powerless, and it can bring hope.

I don't use the word activist to describe myself. I'm a person dedicated to making the world a better place. Not a perfect place, but a better place. It's caring that does it. People caring about each

* "Lament for a Nation" is the title of a book by Canadian writer George Parkin Grant.

other and the world and nature. That's the first thing—to care enough to do something. Caring is living. People who are so isolated in their own individual way, making their own fortunes, are so removed from the stream of life that I feel very sorry for them.

Currently I'm a volunteer at the Carnegie Centre with the *Carnegie Newsletter*. I do some writing for End Legislated Poverty's newsletter, *The Long Haul*. I did a lot of research recently to update "Poverty in B.C.," a curriculum package for the B.C. Teachers Federation. Teachers are using my research to make lesson plans. One of the things I learned is that we cannot talk about poverty today unless we talk about it in a global context. It's a global thing.

MUGGS SIGURGEIRSON

I have known Muggs for over a decade, when we both first became involved with the Carnegie Centre. She is a highly energetic woman who is totally dedicated to issues she believes in. In this interview she spoke of only a few of the community and world issues she has been involved with. In 1992 the YWCA chose Muggs as a Woman of Distinction for her work in the Downtown Eastside community.

I was born in North Vancouver in 1943. At that time people who couldn't afford to live in Vancouver lived in North Van. It was clearly a working-class neighbourhood. Most of the people worked at the sawmill or at the Burrard shipyard. My father wasn't formally political but my mother went to all the meetings. She was a member of the CCF (the socialist labour party) from before I was born. She didn't have much formal education but she was an international socialist who believed the world should be socialist.

When I was in elementary school, I remember going to the headquarters for lunch with all my brothers and sisters because my mother would be working there all day during election

More Community Activists: (*Clockwise from top left*) Alicia Mercurio, Larry Loyie, Muggs Sigurgeirson, Libby Davies.

(*Clockwise from top left*) Claire Culhane, Raven, Sandy Cameron.

campaigns. The men had paying jobs and the women were homemakers who did all the work at the campaign offices. What I remember most clearly is the good food: the campaign was one big potluck, with homemade pies and homemade bread. We never ate better.

By the time I was socially aware it was the 1950s, the McCarthy era. There were witch hunts within the CCF, people who were Trotskyists were beat up. I became involved in the young people's CCF and was one of the founding members of the New Democratic Party NDP. I was also involved with the friends of Cuba, doing education about the Cuban revolution, and in the peace movement. When I was seventeen or eighteen I was kicked out of the NDP because I attended Marxist classes. The NDP sent people to witness who spoke out in class, and I got expelled even though I was not a Trotskyist. I had some really serious differences with Trotskyists but I thought they could still work for the NDP.

Then it was the 1960s and there was the anti-war movement, the radical left student movement, the beginning of the women's liberation movement, the abortion debate. I was a single parent going to college and my time was completely consumed with meetings on every kind of issue. Every second of your waking day could be political. People were questioning the very existence of our society. I took my child to collective school, bought my food at a collective store—everything in my life was working in a collective direction. In the mid 1970s I began working with SORWUC, the Service, Office and Retail Workers Union of Canada, and stayed there for ten years. We were organizing women who worked in industries that mainstream unions wouldn't touch: restaurants, offices and banks. SORWUC was a grassroots, women-oriented union whose main objective was to organize the unorganized. In the end we had to dissolve the union (in 1985) because the labour laws in the province changed to the point where you had to have lawyers on staff, and without funding we couldn't survive.

In 1985 I was involved in starting the Strathcona Community Gardens and in 1986 I was elected to the Board of the Carnegie Community Centre Association. And here I still am, working at the Carnegie Centre.

RAVEN

Raven is a half-Native woman who has been a community watchdog in the Downtown Eastside for many years.

I was born in North Battleford, Saskatchewan, and grew up in the country. My parents were poor farmers who paid the doctor with vegetables. I have wonderful memories of our little country schoolhouse, which was also used as church and community centre. There were only about thirty children in the school, including grades one to ten, so we all had a chance to express ourselves.

My dad spent his entire life fighting for the rights of others. Tommy Douglas, the founder of the CCF (Co-operative Commonwealth Federation), and my dad were close friends and I was taken to many CCF political meetings at an early age. This, and my father's example, was the start of me being a community activist. Since coming to Vancouver over thirty years ago, I have been involved with advocacy work around welfare rights, UIC (unemployment insurance) appeals, and Human Rights cases. I have belonged to welfare and tenants' rights groups and was involved with the 1984 protests to make CRAB Park a community park.

On December 22, 1975, my son was born. This was also the day Premier Bill Vanderzalm made his infamous statement about giving people on welfare shovels and putting them to work. When my son, Wayne, was about three years old, we went to a protest at Vanderzalm's amusement park. Wayne wore a hard hat and carried a lunch bucket and a shovel. I made a sign saying, "Here is my shovel. Where is the job?"

I've also been involved in keeping casinos out of the Down-

town Eastside. A casino would mean moving thousands of homeless people and low-paying tenants out of the community. Small businesses would be wiped out, the traffic would become unbearable, and organized crime would move into the area. The police are already unable to cope with the crime; a waterfront casino in the downtown area would make their jobs impossible. We say "No Casino—Go to Reno!"

Whenever I feel discouraged, I feel Dad and other old-timers looking over my shoulder, telling me to sock it to the oppressors. We're still fighting the same battles they fought in the 1930s. We have to keep fighting for future generations.

YASMIN JIWANI

I met Yasmin at a conference. She impressed me with her dedication to ending racism. When I asked her to participate in my book, she said she wasn't comfortable focusing on herself; she preferred to focus on the larger issues and the many others who have struggled before her. Here are excerpts from her responses to my questions.

I don't think anyone is inherently an activist. The process of politicization and of wanting to change the world follows from the oppression that one experiences and from following many others who have paved the path of activism before us. I have been politicized and mobilized to challenge inequality in its multiple forms because of the work of other women of colour who confront racism, sexism, classism and homophobia. Women who are highly qualified but can't get jobs that fit their qualifications because of the colour of their skin; women who work under hazardous conditions, suffering environmental toxins and minimal pay to harvest the food we eat; women who are subjected to racist attacks and made to feel they don't belong in this country which prides itself on its tolerance; women who are tokenized by the mainstream; women who suffer backlash

because they dare to voice opposition to those in power. These are the women who inspire my work, and whose struggles inform my struggles. And my desire for social change is spurred by the pain of feeling excluded, being negatively stereotyped and dismissed and mocked. Many times I have been propelled toward social action because of outrage.

I was born in Kampala, Uganda, shortly after the country moved from being a British colony to being a neo-colonial nation. It was a multicultural society structured on foundations of racism, and the signs of an informal apartheid were everywhere. This system worked well as long as everyone "knew their place." Moving to England, I discovered that the same ethos was operating. Knowing one's place meant accepting that we did not belong in this predominantly white, colonial motherland. It didn't matter that we were British citizens or that the imperial powers had set into motion the political coup that resulted in our banishment from our land of birth. In the early 1970s in England, people were mobilized against the "invasion" of Asians from East Africa.

When we moved to Canada, we were amazed to discover the strong legacy of racism that persists here. I remember hearing about houses that were fire-bombed simply because their owners were South Asian. I remember sitting on crowded buses where no one wanted to sit next to me, and seeing graffiti on walls that said "Go home Paki." Where is home for a people of the Diaspora? Every day we are bombarded with images and stories that indicate, subtly and overtly, that people of colour are marginal to Canadian society, that they are perpetually immigrants, no matter how many generations they have lived and died here.

In 1989, a group of us organized an international film and video festival celebrating the work of women of colour. I worked as a publicist for this project (called In Visible Colours) and tried to interest the mainstream media in our conference and film and video festival. They weren't interested, because we didn't fit the frame that define people of colour as victims or

criminals. Despite the lack of local media attention, the festival was a major success and received much international coverage.

Later, working as a civil servant for the federal government, I saw firsthand how the policies that were supposedly for the benefit of minority groups got twisted to fit the highly racist mentality of bureaucrats. Women of colour working within the system were powerless to change the situation; often they were supervised by white women.

Most of my work deals with raising consciousness by talking and writing about issues facing women of colour. There are many places where such talk is not welcome and we are branded as too demanding. Is it too demanding to fight for human rights, human dignity? I think not. I continue to work with organizations like the British Columbia Organization to Fight Racism, the South Asian Women's Action Network, the Committee for Racial Justice and the Vancouver Status of Women. It is only through collective action that there is some degree of safety for the kind of work we do.

I do not stand alone. There are many who have undertaken this struggle before me, and it is on their shoulders that I stand.

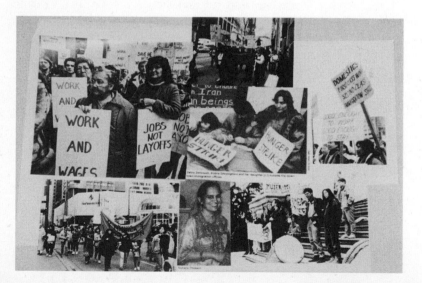

Closing Thoughts

Recently I asked my friend and mentor Sandy Cameron why he had taken me to the old tree where I first got the inspiration to write. Here's what he said:

> I thought the best thing to do would be to go somewhere where it was quiet. Being around trees calms me down—I love to go into the forest—so I thought that it might help calm you. I knew the area and I knew there were these giant cedar trees there. That tree would have been a thousand years old. There's something about size that is calming—elephants are calming, mountains are calming, big wolves are calming—and there's something about age that is calming. And it gives you perspective. Like here we were, upset about something that happened on a particular day, and here was a tree that was one thousand years old, looking at us and saying, "What in the world are you upset about?"
>
> And you calmed down right away. I said, "Sheila, what do you want to do?" And you said, "I want to write."

There is a large chestnut tree on my street which I can see from my window. A number of years ago when I needed a higher power to turn things over to, I chose this tree to be my spiritual symbol. I had struggled with different religious beliefs and denominations all my life, and I could never find an organized spiritual group that I could relate to. But I have a history of talking to trees and plants, so I felt good about adopting this tree as my higher power.

When I have a problem now, I look out my window and speak to my chestnut tree. It really seems to help. Sometimes I

go outside and touch my tree. I feel a little embarrassed if any-
one is walking by, but I love looking up into its huge branches as
I stand underneath it. I ask for help with problems. Mostly I
seek insight to change what I need to change in me, so that I can

keep working to make the world a better place. When I'm really pissed off about something, or stuck, I can look at my tree and take time to think, and usually a solution comes.

When my previous publisher turned down the first draft of this book, I asked my tree for help in getting it published. I spent several years working on it and during this time I underwent two surgeries, was diagnosed with Graves disease and worked with three different editors, each of whom suggested a different direction. I almost lost hope of seeing this book published. I'm not an easy writer to edit. My work is messy sometimes and it's not on a computer disk and not spell-checked. But after that difficult process, my book did get back on track, somewhat as I had visualized it in the first place. If you are reading it now, my tree has helped it get published.

My tree is very patient, something which I, too, have had to learn to be. As I am completing this book, the Woodward's housing issue hasn't been resolved. Mole Hill, which we thought was a certain victory, is in jeopardy. My community is being torn down around me and replaced with giant ugly condos. Nobody waves good morning because their windows only open an inch or two. The theatre at Barclay and Denman, which for years showed foreign films and offered seniors and people with disabilities reduced rates, is being demolished. More condos and a bank are slated to replace it. Vancouver is becoming a city of strangers, the heart ripped out of its communities.

A few days ago Pat McCreery, from the Raging Grannies, called me in tears, saying Doris Rands had died. She was one of the first members of the Grassrooters, and was also part of the Raging Grannies and End Legislated Poverty. At eighty-plus, she was a tiny, frail-looking woman but such a strong activist. Doris's first and lifelong struggle was opposing war. She was active in the movement against nuclear weapons testing and was a founding member of the Voice of Women. She also

campaigned for community health clinics, was a supporter of aboriginal and gay rights and was a children's advocate and a feminist and socialist. I saw her as a gentle lioness who always got her point across without yelling or cussing. I really loved her activist spirit. Pat is also in her eighties, and she too never misses a day of supporting community issues. Like Doris, she is frail but strong in spirit. These women are great role models for me.

Shortly before Doris died, I went to visit her in the hospital. She was in a head brace, forced to lie flat on her back. She said, "Don't squeeze me." "Here," I said, "hold my finger."

"Sheila, I've had the biscuit," she said. "I've had the biscuit." I told her no, she had to be around for my book launching. "I'll try," she said. Now she has passed away, and I will miss her so much. There are many unknown heroes and heroines out there, and Doris Rands was surely one of them.

When I was at the Gay Pride parade in Vancouver just recently, I kept thinking I saw Alan Alvare, but then I remembered that he, too, had died. Alan had been a Catholic priest and later a welfare advocate for First United Church. I interviewed him when I was working on *Under the Viaduct*, and I missed him at this year's parade. He was a strong anti-poverty activist and gay activist.

One of the most powerful moments of the parade was when the Dykes on Bikes passed by, some of them bare-breasted. Not far behind was the new Vancouver chief of police. It goes to show that change does happen.

It's always difficult for me to end my books. I want to hang on and say goodbye and then one more goodbye. This book was almost typeset when we got news of the death of another activist, known as Princess Diana. We were both from England, we both disliked royal protocol and suffered from eating disorders. The work she did bringing issues like land mines and

bulimia and battered women to world attention is being called "charity work," but I want to claim her as an activist. She worked to change the world for the better; that is not charity but social activism.

If you have gone to the trouble of getting my book from the library or buying it, I know you probably care about the injustices I write about. Please, if there is an issue that you have read about that triggers an I-wanna-do-something feeling, just seek out other people working on the issue, make phone calls, look up groups in the phone book, get on the Internet (I haven't mastered the Internet yet, or should I say madamed it). This book is an sos. Please send help. Please send help.

One person can and does make a difference. Empower yourself and others by fighting back. You may be the special person that will be the catalyst that starts a movement that becomes so strong that no one can break it.

Bibliography of Key Sources

Am I Missing Something Here?, booklet produced by the Canadian Labour Congress, Ottawa.

Big, Bold and Beautiful, by Jackqueline Hope (Toronto: Macmillan Canada, 1996).

Carnegie Newsletter, a publication of the Carnegie Community Centre Association, Vancouver, B.C. Various dates, 1995–97.

DERA *Newsletter*, produced by the Downtown Eastside Residents' Association, Vancouver, B.C. Various dates, 1995–97.

Dispatches from the Poverty Line, by Pat Capponi (Toronto: Penguin Books, 1997).

Fat!So? #2, Copyright © 1994; #4, Copyright © 1995, Marilyn Wann, San Francisco, CA.

Fighting for Community: Stories from the Carnegie Centre and the Downtown Eastside, by Sandy Cameron, published by the Carnegie Community Centre Association, Vancouver, B.C., 1996.

The Gazette, Montreal, daily English-language newspaper. Various dates, 1970–71.

The Long Haul, End Legislated Poverty's newspaper, Vancouver, B.C. Various dates, 1995–97.

The Mole Hiller, Mole Hill Living Heritage Society newsletter, Vancouver, B.C. Various dates, 1996–97.

NAPO*news*, a publication of the National Anti-Poverty Organization. Various dates, 1995–97.

The National Action Committee on the Status of Women's Voters' Guide: A Women's Agenda for Social Justice, ed. Nandita Sharma (Toronto: James Lorimer & Co, 1997).

No Fat Chicks: How Women Are Brainwashed to Hate Their Bodies and Spend Their Money, by Terry Poulton (Toronto: Key Porter Books, 1996).

Nowhere to Live: A Call to Action, a publication of the Lower Income Urban Singles Task Group, British Columbia, 1995.

Opening Our Doors: Respecting Low-Income Canadians, Report from the National Anti-Poverty Organization, Ottawa, 1997.

Poverty Profile 1995, a publication of the National Council of Welfare, Ottawa, 1997.

Shocking Pink Paper, a publication of The National Action Committee on the Status of Women, Toronto, 1997.

The Ubyssey, published by the Alma Mater Society of the University of British Columbia, 4 March 1988.

Vancouver Sun, daily newspaper. Various dates, 1995–97.

Welfare Changes, Does B.C. Benefit? Workfare Hurts One and All submission to the NDP review of B.C. Benefits, Vancouver, B.C., December 1996.

Widening the Gap, booklet published by the Social Planning and Research Council of B.C., May 1997.

1997 Seniors Election Handbook, booklet published by One Voice, The Canadian Seniors Network, Ottawa, 1997.

30 Million Good Reasons to Have National Standards for Welfare, An Action Guide from NAPO, Ottawa, 1995.

About the Author

SHEILA BAXTER is a poet, writer and activist. She raised four children and is a grandmother of eight. For thirty years she has been an activist addressing poverty and other social issues that she feels strongly about. She is the author of three previous books on poverty and was the inaugural winner of the VanCity Book Award in 1992. Presently she is involved with the Carnegie Community Centre and End Legislated Poverty.

Press Gang Publishers has been producing vital and provocative books by women since 1975. For a complete catalogue, write to Press Gang Publishers, #101 - 225 East 17th Avenue, Vancouver, B.C. v5v 1A6 Canada, or visit us online at http://www.pressgang.bc.ca

SELECTED TITLES

Sunnybrook: A True Story with Lies
by Persimmon Blackbridge

ISBN 0-88974-068-2 cloth; ISBN 0-88974-060-7 paper
Lavishly illustrated with full-colour images throughout, this is a fast-paced and very funny novel about disability issues. Shortlisted for a 1997 Lambda Literary Award.

Beyond the Pale (A Novel)
by Elana Dykewomon

ISBN 0-88974-074-7 paper
An extraordinary testimony to the lives of Jewish lesbians who immigrated to North America at the turn of the century.

Call Me Crazy: Stories from the Mad Movement
by Irit Shimrat

ISBN 0-88974-070-4 paper
A moving and inspiring account of resistance against psychiatric abuses, and the creation of humane alternatives.

Two Ends of Sleep
by Lizard Jones

ISBN 0-88974-072-0 paper
Often hilarious and always illuminating, *Two Ends of Sleep* is a quirky fictional account of living with Multiple Sclerosis.

Cereus Blooms at Night
by Shani Mootoo

ISBN 0-88974-064-X paper
Part magic realism, part psychological drama, this haunting novel explores a world where love and treachery collide. Short-listed for the Chapters/Books in Canada First Novel Award and the Giller Prize in 1997.

I Am Woman: A Native Perspective on Sociology and Feminism
by Lee Maracle

ISBN 0-88974-059-3 paper
Lee Maracle's words touch people of all cultures who are committed to social justice.